A SCOTTISH JOURNEY

DAVID PATERSON

WILDCOUNTRY PRESS

Cover: Loch Duich, West Highlands

First published in 2003 in Great Britain by:
Wildcountry Press,
Dochart House, Killin,
Perthshire, Scotland FK21 8TN.
(www.wildcountry.uk.com)

ISBN 0 9521908 8 5
Cataloguing in British Library publication data applied for.

Paterson, David
A Scottish Journey
1. Scotland
2. Travel
3. Photography

Designed by Wildcountry Press
Originated & printed by
CS Graphics Pte Ltd,
Singapore.

CONTENTS

For my parents, in a special year

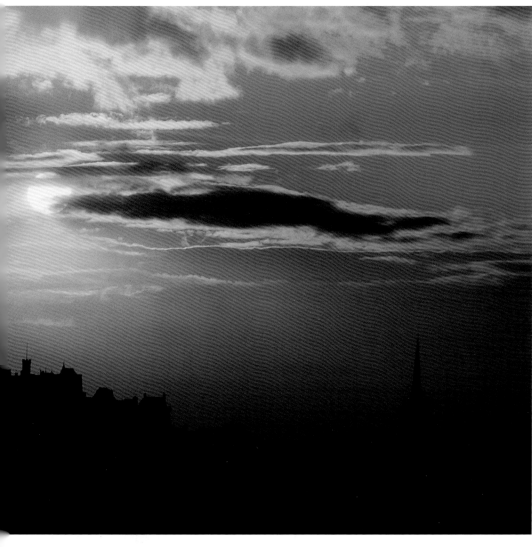

Edinburgh Castle from Salisbury Crags

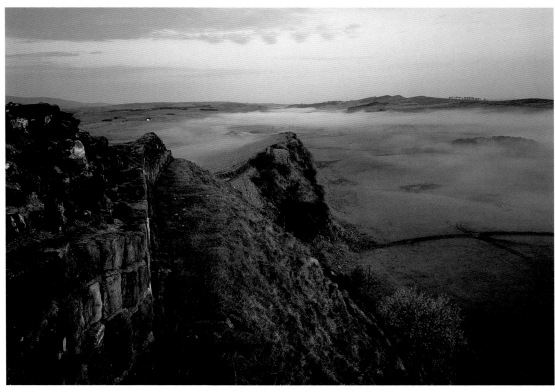

Borderlands…Hadrian's Wall near Housteds

INTRODUCTION

BY
DAVID CRAIG

Scotland stretches from the Mull of Galloway on the south-west mainland to Herma Ness at the north tip of Shetland and from Lamba Ness in north-east Unst to Berneray (Barra Head) at the tail of the Outer Hebrides. That is to say, from 54.6° N to 60.8° N and from 0.50° W to 7.32°W. That is to say, Scotland occupies a space on the globe roughly 510 miles from south to north and 260 miles from east to west.

Such are the strict coordinates. As we experience it, the southern bound of Scotland runs south-west from the mouth of the Tweed to the Solway Firth. The major geographical frontier is the range of rounded hills we call the Southern Uplands; and the Roman Wall is an extraordinary stone remnant of what invaders from the south must have perceived as the terminus of their civilisation and the gateway to something else.

The shape of this land, with its central mass and its many islands, is so familiar that it is hard not to think of it as permanent, an entity that always had to be and always will be. The angular eastern sections—Caithness and Buchan near Peterhead and Fraserburgh—jut into the North Sea like chins. The lowland belt from the Forth to the Clyde, from Edinburgh to Glasgow, makes the waist of the country, narrow enough (about 25 miles) to be spanned by a canal. The west is wildly fretted and penetrated by the sea where steep-sided valleys have been drowned and a mountain such as Liathach plunges for more than 3000 feet straight into the salt water of Upper Loch Torridon.

The low lands of the country are wonderfully varied. In Strathmore, between Perth and Forfar, gently rising fields with a warm-brown soil grow tons of potatoes and raspberries. On the island of Vatersay, grassland spreads like a green mantle over the boney terrain and gives pasture to more than a hundred cows. The mountains vary from the grotesque oddity of the Quiraing in Trotternish, northern Skye, with its spires of conglomerate and oozing black gullies, to the sub-Arctic massif of the Cairngorms where the lapse of the geological ages, the upheaving of the plutonic (granite) rock and the carving of the ice, have created a terrain so large and gradual that it is utterly calming to walk through its passes or climb to its summits.

The islands vary from the Bass Rock in the Firth of Forth, where 70,000 gannets with ice-blue eyes nest on tumps of rotting seaweed, to Barra in the Outer Hebrides, where a Gaelic-speaking people can tell exact stories of how their forebears were evicted from their crofts on the best land a century and a half ago and in some cases reclaimed them. The towns and cities vary from the compactness of Stornoway, where all streets lead down to the harbour, to the huge labyrinth of Glasgow, swarming with energy in spite of losing its shipyards, mills, and factories. The villages vary from Diabaig in Wester Ross—exquisitely sited above its natural harbour, starting to fail in the Sixties, revived first by the oil-rig dock at Kishorn and then by the salmon farm in the almost landlocked bay—to Strathdon in Aberdeenshire, famous for the Lonach Gathering

on the green show-ground between the mountains and perhaps enlivened still more from time to time by the presence of Billy Connolly as the laird of Candacraig.

Probably any country, from Belgium to the Philippines, sees itself as special—specially characterful and various, specially ill-used by some powerful neighbour and/or invader, specially talented in spite of it all. Scotland has had a good enough opinion of itself lately to manoeuvre halfway towards independence—the political form of the vaguer thing called nationhood. At one time you might have thought to define the country by negatives: sold out to England by the Act of Union in 1707; the Highlands savaged by the Clearances between 1800 and 1870; disproportionate numbers slaughtered in the Great War, leaving their names in long lists on the memorials which make a ghoulish figure in thousands of towns and villages; losing 40,000 people a year by emigration. Now morale is rising again, based on the degree of affluence that has flowed from North Sea oil and gas. Emigration loss has been halved, and people from all over the country are working on the oilrigs. In my hometown of Aberdeen the published roll of the dead from the disastrous fire on Piper Alpha in 1988 named addresses in dozens of streets. They are commemorated now in a superb rose-garden and sculpture near the maze in the park at Hazelhead. This industry has almost supplanted fishing on the east coast and will stand working-people in good stead when the cod and haddock fail altogether, although the undersea minerals will run out in their turn. Perhaps the oil in the seabed of the Atlantic will fuel a further regeneration of the Highlands, unless it is shipped ashore by tankers at new depots on the old wharves of the Clyde.

Looking out over the country which has been eaten at by mines and military camps, and glaciers and floods, and railways and motorways, and logging and the breaking-in of fields, it is usual to say, The land abides. So it does, most of it, so much so that any drastic alterations to the shape of Scotland are more or less unthinkable. Of course the ocean can rise and turn a peninsula into a chain of islands, it can retreat and an island loses its entity. (How far are Vatersay, Eriskay, and Berneray separate islands now that they are linked by causeways to Barra, South Uist, and North Uist?)

This is not an event we normally perceive in our lifetimes, or even in historical times. If it happened, we might well be dismayed at the deforming of the cherished shapes. In the Seventies, after an unforgettable family holiday on Jura, my youngest noticed that the island had been left off the map then in use for the BBC weather forecast and was delighted when it was reinstated after he had sent them a letter. Jura itself does change, slowly. Its western shore is rising over the millennia, now the downward pressure of ice has been removed. Rock arches hollowed through by the sea have been left high and dry and they stand up from grass-grown shingle like monuments to another age, or prehistoric animals petrified in mid-stride. In caves nearby wild goats go to die and leave their skeletons, horns sprouting from the skull with their tips curving back nearly to the tail-end of the spine.

One of the most delightful things to come across is a place where life has changed greatly and the layering of it is plain to see. A remote one is Dunadd, near Crinan on the coast of Argyll. The Pictish kings of Dalriada were crowned and anointed on this hill, with one foot in a hol-

low carved out of a rock near its summit. To the north a river winds through wetland called Moine Mhor, the Great Moss. This small watercourse was once navigated by ships bringing in French wine to a medieval town of wattle-and-daub protected by stone ramparts, where metals were worked in crucibles and brooches were cast in moulds of clay and stone. Here is a place whose old life is still visible on the very horizon of tangible history. In the heartland of Scotland, Edinburgh's castle on its great rock binds land and people together in an extraordinary knot or clench. I will always have mixed feelings about it. It is a palace and a fortress. The basement is riddled with dungeons. Bloodshed was planned here. Rich and powerful people roosted here, comfortably above the cramped and festering premises of 'their people'. The last prisoner shut up in the dungeons, in 1919, was Davey Kirkwood the Red Clydesider, later an M.P. He felt "a done man" as the damp stone closed round him. Outside, on the growthy slopes of the citadel, you can imagine for glimpses that you are amongst a wild nature of thorn bushes and luxuriant grasses and flowers. Volcanic rock arises darkly through the leafage. The great crag was shorn on its east side by a glacier, preparing a route for the main rail-track out of Waverley to north and west. Wide-mouthed cannon poke out from the battlements. Up above, in tourist-ville, hundreds of people from all over the world enjoy a good lunch, file respectfully past a sort of shrine enclosing the Crown Jewels, and giggle at the guide's anti-English jokes. In a war-memorial chamber you can look for the name of a relative in the interminable lists of the dead. The whole mixture of barbarity and civilisation calls for a strong stomach.

For a time in the Seventies a style shone briefly on our TV screens. The land was filmed from a helicopter circling low above it. Islands revolved. Cliffy coastlines swam close as though seen by a gull. Beaches streamed past in long unfolding brown or pale-gold stretches, reminding us of the Celtic word for them, strands. The camera peered down into the cores of ancient towers. Low sunlight at the beginning and end of the day defined the wrinkles of new ploughland and old earthwork with a distinctness we had never seen before. The country stood out both as a cluster of footholds offered to humanity by the accidents of the Earth's evolving and as a huge artefact tooled and tooled again by people in their efforts to subsist. Once, the story was that all this was made by supernatural beings, for example the Caillach Bheur or Earth-mother who shaped the mainland and tipped off the Hebrides with the last soil and stones left in her creel. Now we know that we are a load on the surface of a tectonic plate. Primeval rivers carried down the sand that was compressed into the Old and New Red Sandstones. Volcanoes volleyed out magma that solidified into the columnar basalt of Staffa, the Sgurr of Eigg, and the Kilt Rock on the eastern coast of Trotternish.

Populations of plants invaded from warmer latitudes and rotted over thousands of seasons to make peat, where decomposing was slow and partial, and soil where it was more complete. For some, the living plants that thrive in Scotland are epitomised by heather, purple and honey-smelling in August—judged by a famous English visitor to be "one sullen extent of sterile vegetation". For others again, more typical plants would be barley, shimmering and darkening like green silk as the breeze blows over it, and oats, frosty blue-green ripening to pale gold in September. Once, a widespread plant was the Scots pine,

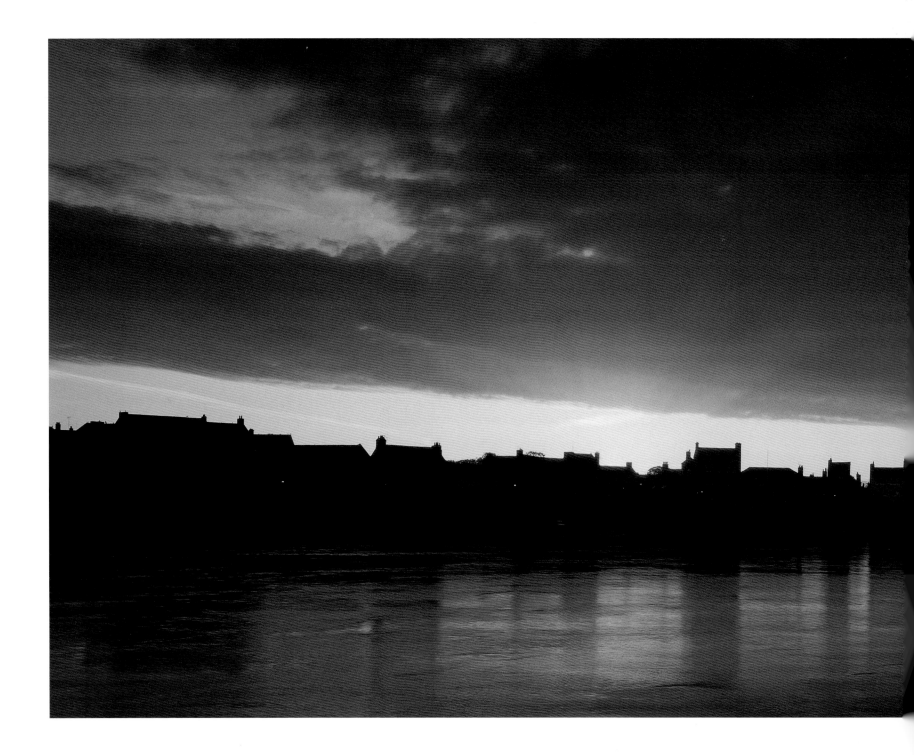

Borderlands…Berwick upon Tweed, fought over for centuries

logged out for building timber and even for charcoal, especially when there was an arms race and the furnaces worked full-blast to make cannon. Now you have to search for the Scots pine and find it in a place like Rothiemurchus in Speyside. There you can rediscover the entrancing quietude of aboriginal forest as you walk for an hour or more between the bronze trunks, under massed needles, through the blaeberry bushes that can flourish because the forest-canopy is well spaced out. You can even see a red deer, although it will be only two-thirds the size of the animal that flourished here until it was forced out by spreading agriculture onto the bare mountains.

Scotland has no sizeable plains, not on the Irish, let alone the Russian or American, scale. The habitable areas are slender north and west of the Great Glen which splits the country from Inverness to Fort William, more expansive in the Lowlands. Even so, you are rarely far from mountains and this has worked on our self-image and our imagination of what life is. If there is always a blue hill rising to define your frontier, you can feel both sheltered and hemmed in. Your country becomes a place to leave for fulfilment or adventure, to return to when you feel the need of a nest or a harbour. In the red centre of Australia, or the gritty expanses of the American desert states, or on the banks of the Dnieper flowing for hundreds of miles through the Ukrainian plain, I feel my identity thinning, the sheer scope of the Earth minimising me. In Scotland I feel situated and confirmed. Yes, my life is short and I am one among billions, like one fir in a Canadian forest or one anchovy in the ocean. I also belong. It is not just because I know that my father's father sailed from this harbour to fish in the Atlantic, my mother's father brought his bride here from across the North Sea and taught in this school. It is also because the whole country feels knowable and can be encompassed. Although I live (like thousands of other Scotsfolk) outside my native country, I would feel bereft if I could not easily re-enter it and sense its familiar fabric folding round me. Across that pass lies the next strath, showing its greenness in the distance like a promised land. At the mouth of this river welling up through the gravel of the high plateau lies the city which both shelters us and sends us out into the rest of the world.

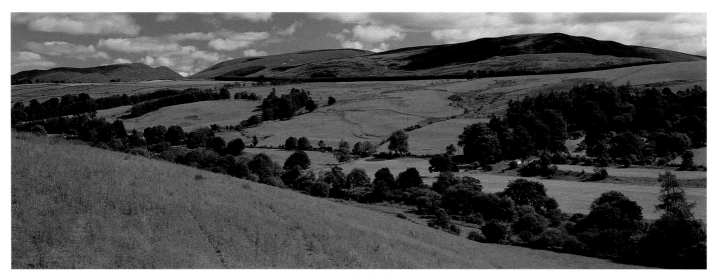

Annnandale, Borders

PHOTOGRAPHER'S PREFACE

BY
DAVID PATERSON

Perhaps the title of this book should refer to two journeys—a lifetime's journey around Scotland which has taken me to live in many wonderful places—and the continuing journey which more than thirty years as a photographer has entailed. The first includes being born in Perth and spending early years in Fife and Dumfriesshire, schooldays in Loth and Golspie in east Sutherland, student years at Edinburgh University and much of the time since then in Edinburgh, Morar and Glencoe.

My constant travelling as a career photographer has taken me to almost every corner of Scotland and has lasted more than three decades. (There are a few islands which I haven't yet managed to reach yet, but work on a new collection of photographs on the Highland Clearances will fill in most of the blanks.) I never tire of this journey, nor of the glorious landscapes we are lucky enough to live among, but which we take too often for granted.

When selecting the photographs for the book I tried hard to remain impartial and to let the images select themselves, in a way, in order to avoid 'favourite' parts of the country taking the lion's share of space. But I am only human, and two areas of Scotland fought their way to the front whenever a debate arose as to whether this image or that should go in. Those areas are Glencoe, where I now live, and Sutherland, where I was brought up. I have indulged myself with a long section on Glencoe and Lochaber, and while the name Sutherland does not appear in the list of contents, just see 'Northern Highlands'.

Ardent geographers may find fault with the way I define the regions, but I ask their indulgence: the boundaries in the book were drawn to match my own feelings about Scotland, and my collection of photographs—or perhaps to mask its deficiencies—and not always along conventional lines. Thus I take 'Lochaber and Glencoe' to include everything from Rannoch Moor to Ben Nevis because that is my home range. 'Northern Highlands' to me means everything on the mainland north of Torridon.

Normally the question of which part of Scotland I like best does not trouble me much. Especially if the weather is fine, I usually find myself thinking that just where I happen to be at that moment is a firm favourite, because there is almost nowhere in Scotland which does not have features of outstanding quality and beauty. My own third journey, which the book does not deal with, involved travel to many dozens of countries as a photographer. But all those travels and absences, short and long, ended with a return to Scotland, perhaps my only real favourite.

The images in the book are mostly of recent origin, many taken since I returned from London to Scotland in the year 2000, but a few go back much further, almost to my first days as a photographer. The elemental landscapes around us change very slowly in spite of our own worst efforts; only our towns and cities show any substantial change since I first ventured out (long ago, it seems) with a camera. But somewhere among these photographs is the thirty-year history of a Scottish journey.

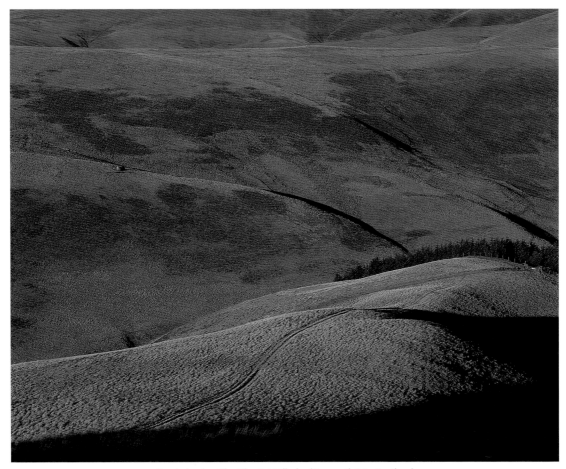

Borderlands…The Cheviot Hills, looking north into Scotland

THE TERRITORY KNOWN AS LOWLAND SCOTLAND can be taken to mean everything which lies south and east of the 'Highland Line', a purely notional feature which runs diagonally from down in the south-west around Rothesay, north towards the Moray coast somewhere east of Inverness. Thus the Lowlands include all of Border region and Galloway, the central belt surrounding Edinburgh and Glasgow, the county of Fife, and all of the country south or east of the high tops of the Cairngorms, which takes in Perth, Dundee, Aberdeen and much else.

When applied to Scotland, the term Lowland often seems to contain at least a hint of inferiority—inferiority, that is, when compared to the Highlands. There are both historical and geophysical inferences here, and both are equally unkind and untrue.

The history of the Highlands has been endlessly romanticised and sentimentalised, often at the expense of the 'Lowlands', whose inhabitants were supposed to have abandoned or opposed the Highlanders at various crucial times. This simplistic view of Scottish history contains many assumptions, foremost among them the idea that Highlanders and Lowlanders can each be thought of as stable and unified groups whose aims and strategies were not only consistent, but always in opposition. The reality was much more complex, and for centuries a maelstrom of shifting loyalties and betrayals saw Highlander fight Highlander and Lowlander fight Lowlander while each raided and fought with the other, and both—together and separately—warred with the 'auld enemy', the English.

In scenic terms there can be little argument that the Lowlands are different from the Highlands. But inferior? I hardly think so; unfairly neglected, perhaps. The very word lowland is largely a misnomer, and a consistent feature of Scotland's southern and eastern counties is how hilly they are. Along the border with England the Cheviots rise to nearly 2700 feet; the Galloway Hills in the south-west reach a similar height, the Lowthers achieve 2400, the Moffat hills nearly 2800. And then there are the Moorfoots, the Pentlands, the Lammermuirs, the Campsies, the Ochils, the Lomond Hills, the Sidlaws and all the rolling tops and ridges of the eastern Cairngorms. Lowlands, indeed!

But the true nature and beauty of the lowland counties hardly depend on their hills, except as a backdrop. The hill-country is there if we want to look for it, the high rolling ridges, the quick-running streams and the empty moors; what takes the eye, however, are the green dales and straths. Rich, flowing farmland fills the valley-bottoms; deep, dark rivers glide through undulating fields and pasture, and dense woodlands clothe the foothills. This is country worth fighting for, and through it are dotted the keeps and fortresses which once policed the region—too many to mention, but with notable examples at The Hermitage and Drumlanrig—and the grand houses and prosperous burghs which followed in more law-abiding times.

Many fine churches, monasteries and abbeys were endowed by the great wealth of the surrounding countryside, at Kelso, Jedburgh, Melrose, Dryborough, Newburgh in Fife, and Arbroath to name a few. Most are now little more than picturesque ruins, but their former power, wealth and influence are easily imagined. In the Lowlands were also founded some of Britain's earliest universities—at Edinburgh, Glasgow, St Andrews and Aberdeen. Small wonder, then, that outsiders from the Vikings to the Highland clans to the English cast envious eyes on Lowland Scotland. They all came—and went—in time, but their strongholds, their genes and their names are still there.

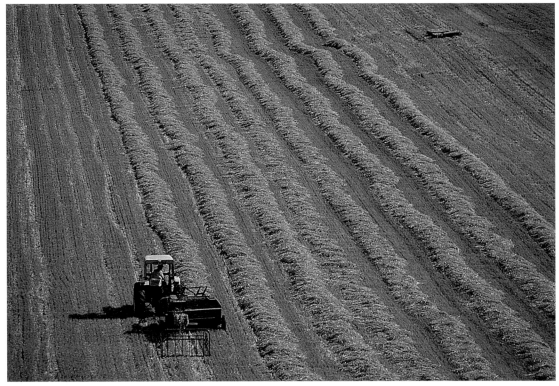

After the harvest; near Peebles.

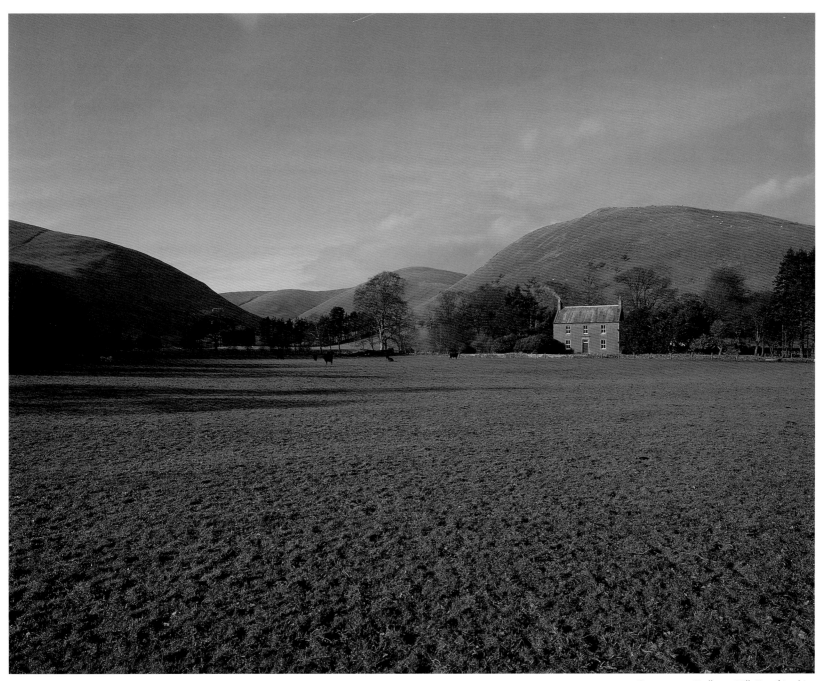

Cottage near Tudhope Hill, Dumfriesshire

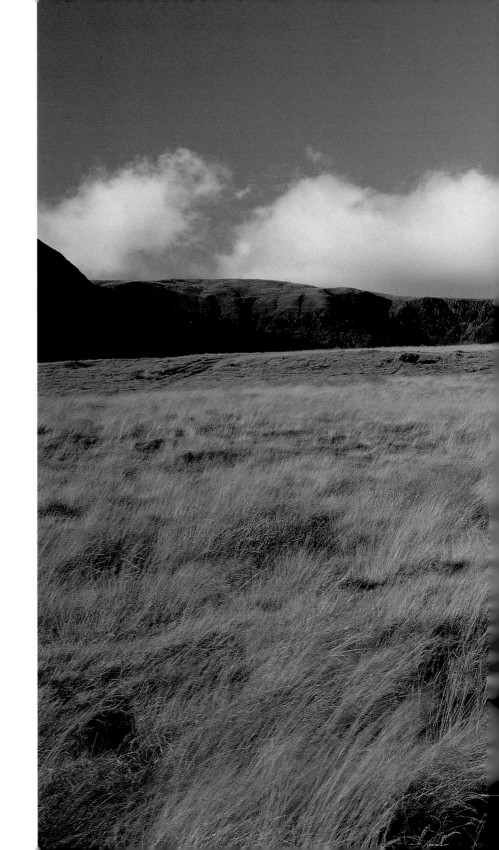

White Comb, near Moffat, Dumfriesshire

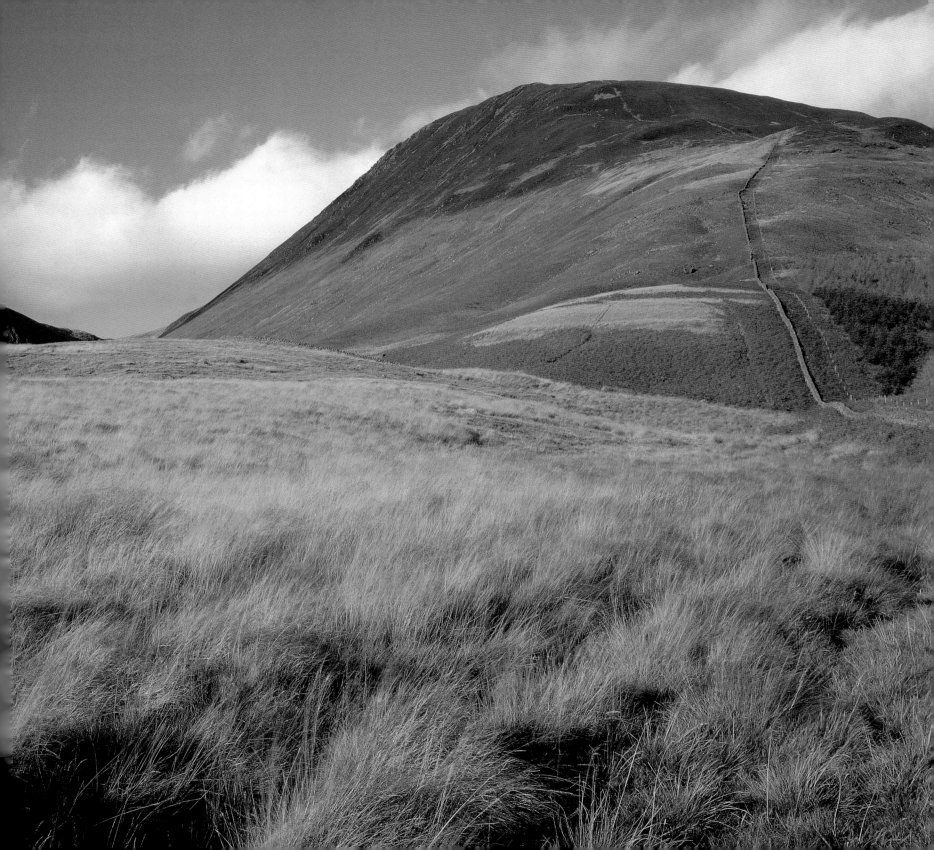

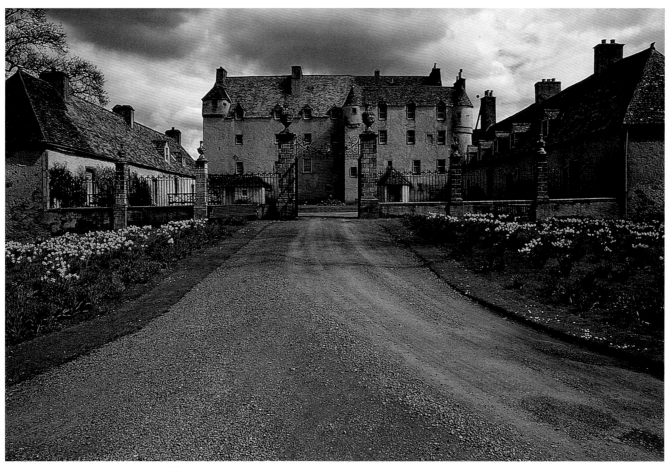

Traquair House, near Innerleithen, Peebleshire

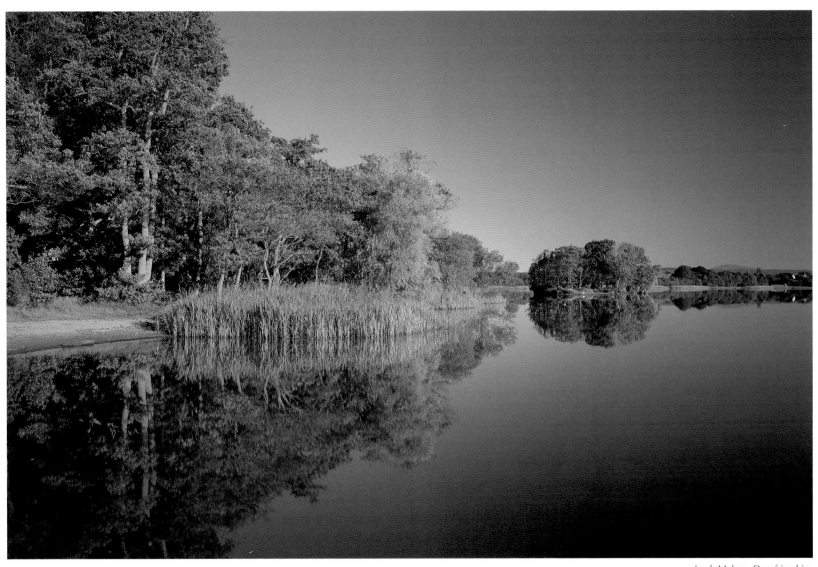

Loch Maben, Dumfriesshire

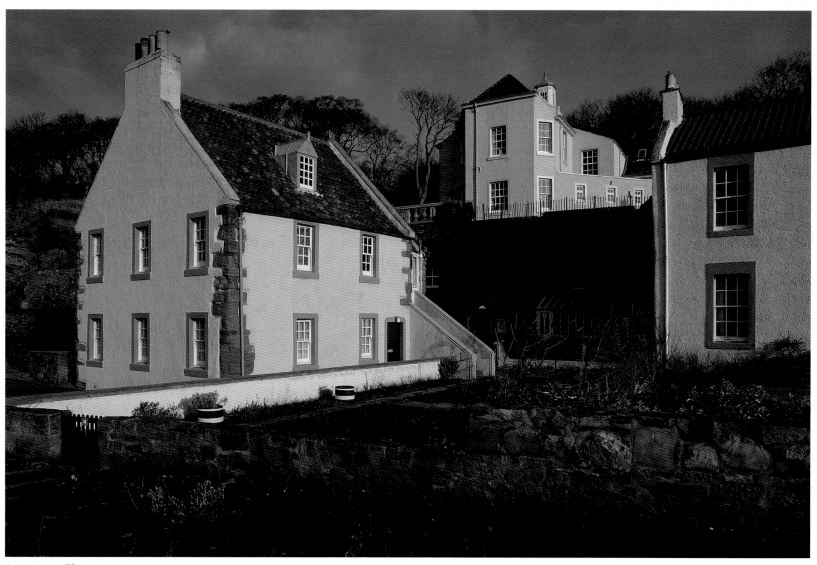

Lower Largo, Fife

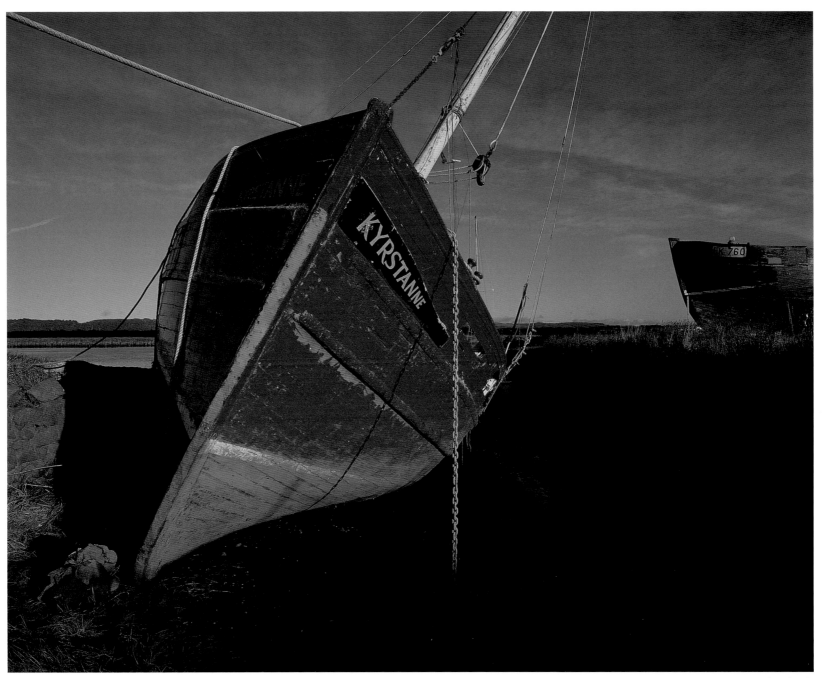

Boats at Newburgh, Fife

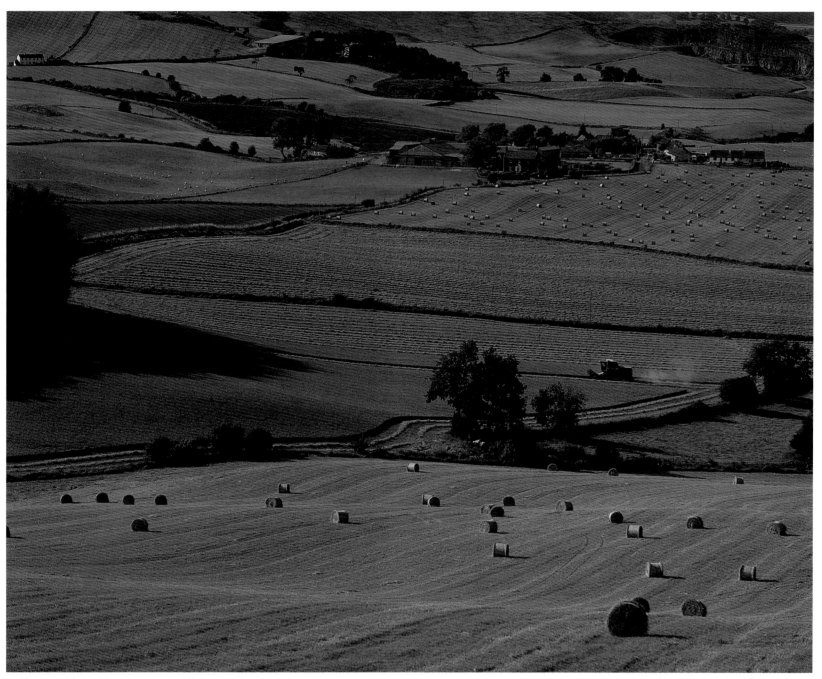

Fields near Lindores, Fife

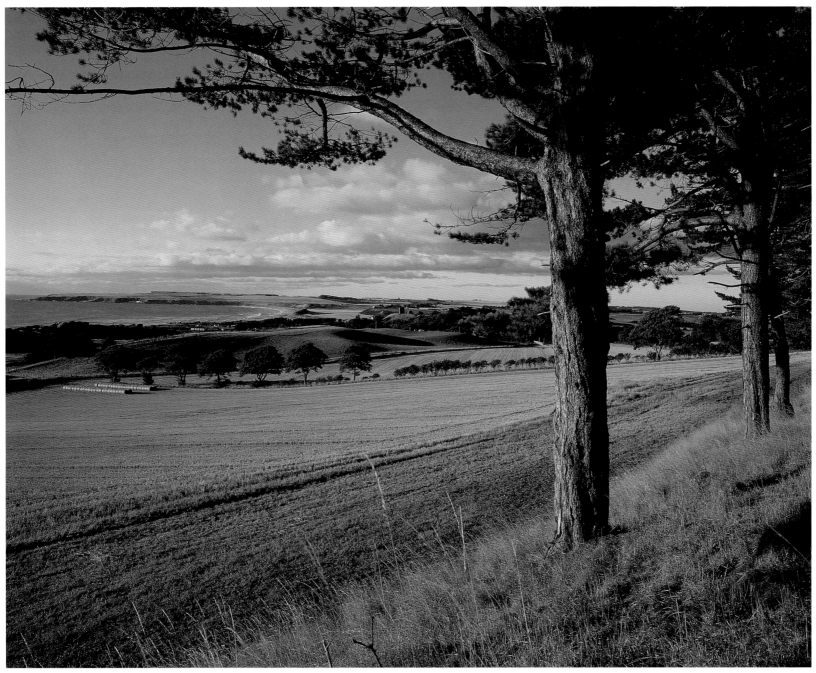

Lunan Bay, near Montrose

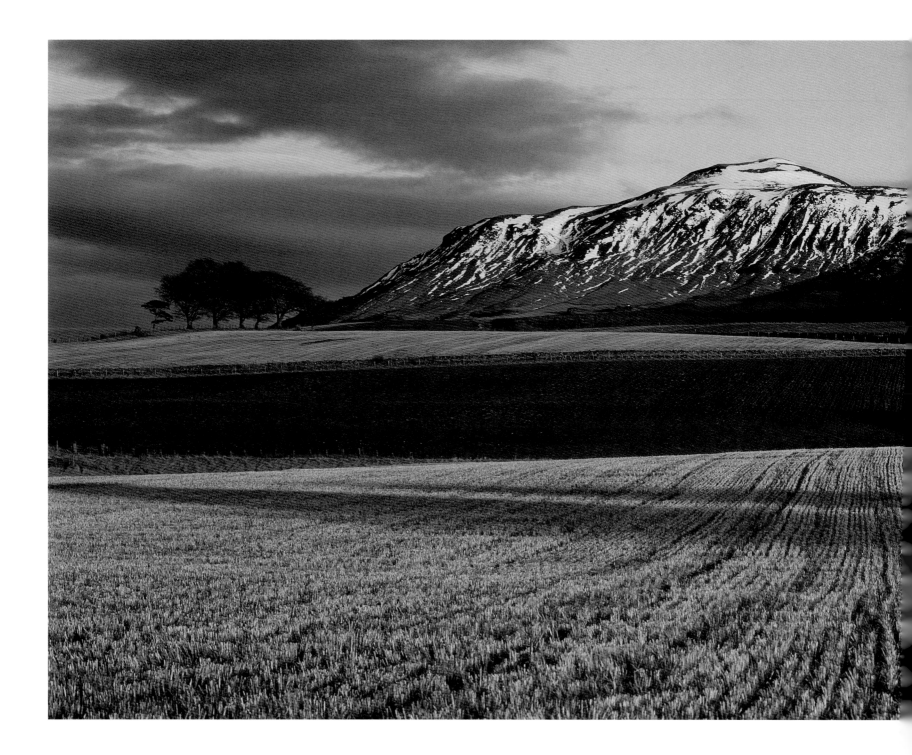

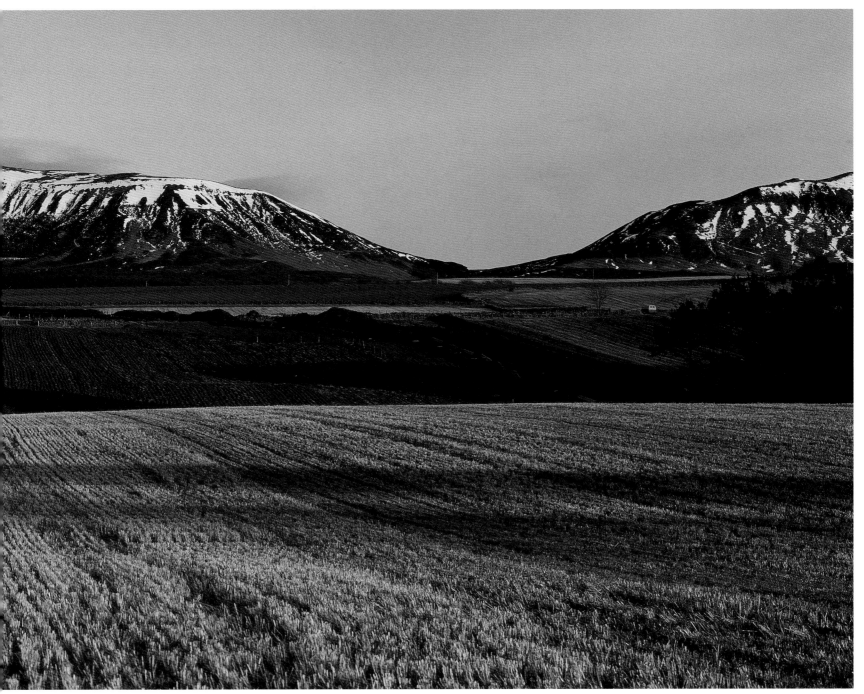

The West Lomond, Fife

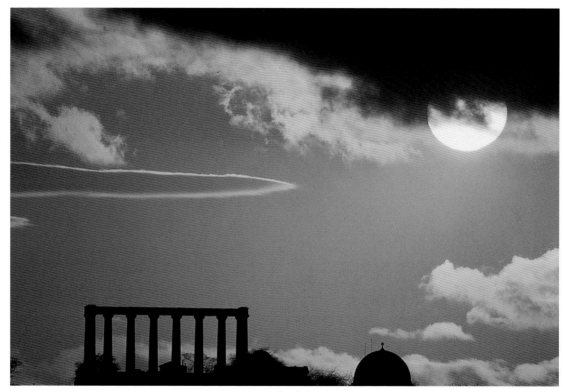

Calton Hill, Edinburgh

THE SCOTTISH CITIES OF EDINBURGH AND GLASGOW are not the only ones worth mention, and fans of Dundee, Aberdeen, Perth and Inverness must forgive me if our political and industrial capitals are the sole representatives here of urban Scotland. I lived for many years in Edinburgh, and as a commercial photographer Glasgow always provided me with one of my biggest markets, so I know them better than the others. That, and the shortage of space, prevents me from doing them all justice.

Another bit of Scotland—another rivalry—and Glasgow and Edinburgh have fought it out down the years, though in this case little blood has been spilt, a burst nose in the pub on a Saturday night now and again, and a stud-raked shin on the football or rugby field, but little more. Quite a lot of hurt pride, but few mortal injuries. As a native of neither city I never felt this rivalry myself but often heard it described or saw it in action. I flatter myself that I can see the best (and worst) side of both towns, Edinburgh beautiful but cold, holding us all at arms-length; Glasgow blowsy and welcoming, with beer on her breath.

Edinburgh always had the name as the architectural jewel, with its iconic castle on the hill and Princes Street, once one of the most elegant streets in Europe (now thoroughly wrecked by ugly modern shops and traffic schemes). But Glasgow probably had the better buildings, reflecting its status throughout the Victorian era as one of the great mercantile cities of the world. Money poured into Glasgow from around the Empire, and great public and private buildings sprang up everywhere as wealthy merchants, civic leaders and churchmen fought to leave their mark to posterity. Many of these buildings are still there, unheralded and unsung, quietly going about their business as offices, meeting-halls and headquarters of various kinds.

Being built on a great river always confers a special atmosphere and of course Glasgow lies on the banks of the Clyde, one of Britain's greatest. The word Clydeside is synonymous with ship-building, but like Princes Street's once-elegant shops, the Clyde's vast ship-yards are little more than a fast-fading memory, the few which remain only serving to emphasize the loss of all the others. Glasgow is nothing if not resilient, though, and along the river-banks other things are stirring—great exhibition halls and conference centres, gardens and restaurant-malls, modern housing, and Victorian warehouses turned into desirable apartments. But there has been a loss of culture, which all the condominiums in the world will not replace.

For all that, Glasgow is a thriving, vibrant city. Edinburgh thrives, too, but in a typically understated way. With the coming of a measure of self-government came ministries, departments, jobs—a parliament building—but this is a city which thrives not on change but on the lack of it. Edinburgh measures its success by how well it maintains its time-warp: a new traffic-light here, a few cobble-stones restored there, all high-rises banished from the city centre, and the new mega-million-pound parliament building hidden down at the foot of a hill where no-one will see it or even know that it exists. That's success for you!

It is beautiful, though. Princes Street still has a charm, and the city is as green as any you could visit. Starting right in the centre with Princes Street Gardens, Edinburgh probably has more parks, gardens and open spaces than any other capital, and all this culminates with Holyrood Park and Arthur's Seat, the biggest city-centre park in the world. How many cities have a mountain at their centre?

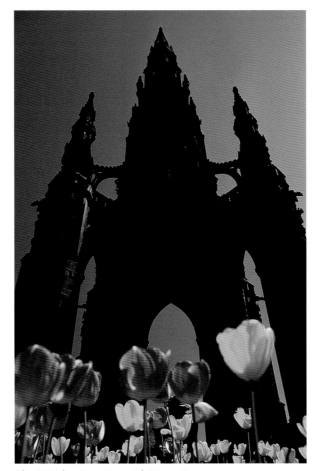

The Sir Walter Scott Memorial, Princes Street

Looking towards Grantown and Leith from Calton Hill

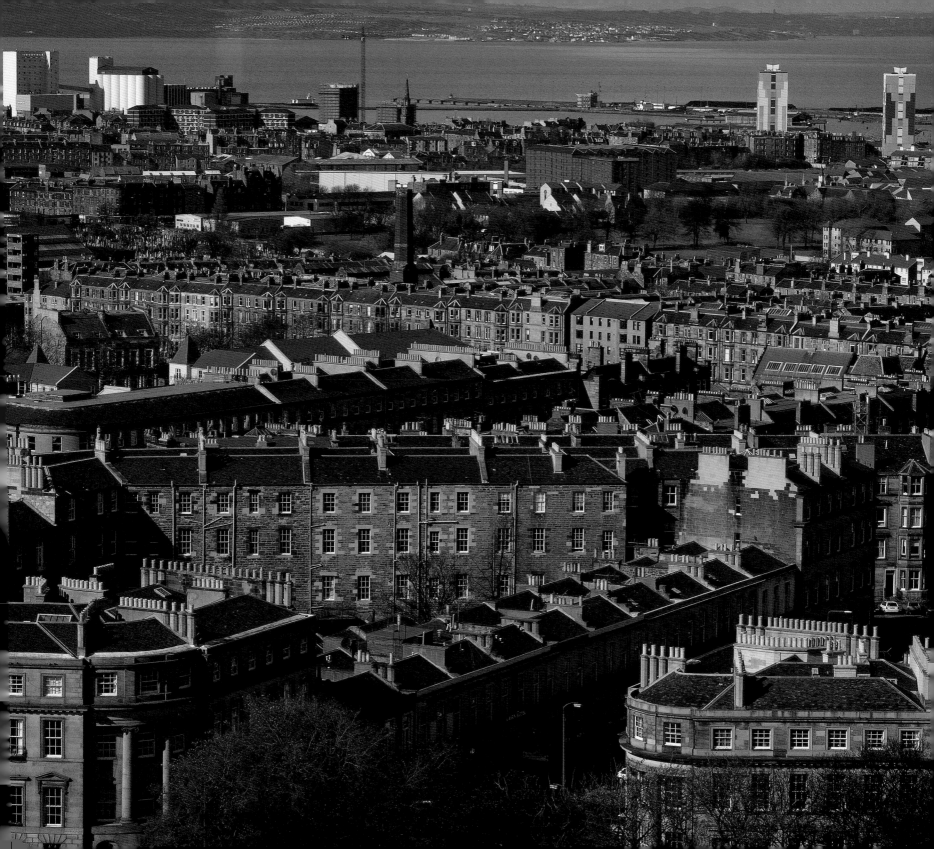

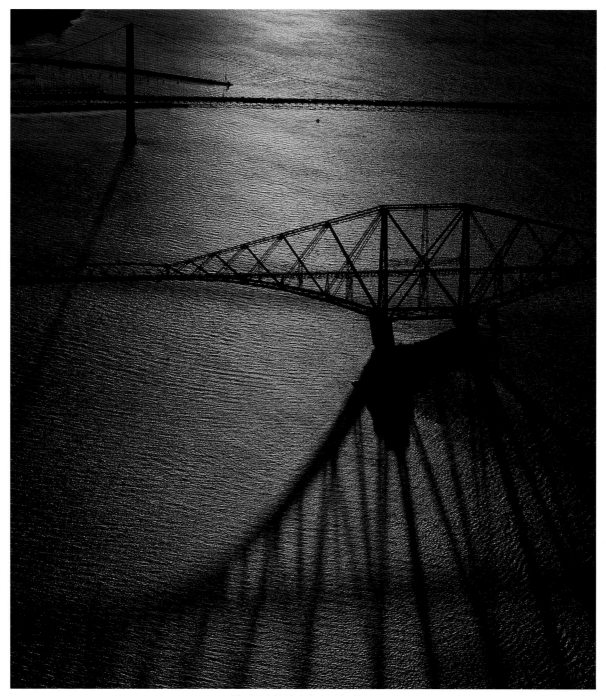

The Forth Bridges in evening light

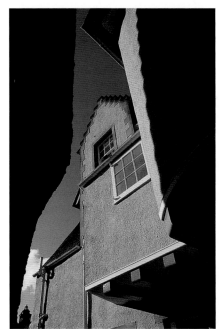

Bank of Scotland, The Mound
Pub door, Tollcross

St Mary's Church, West End
White Horse Close, Royal Mile

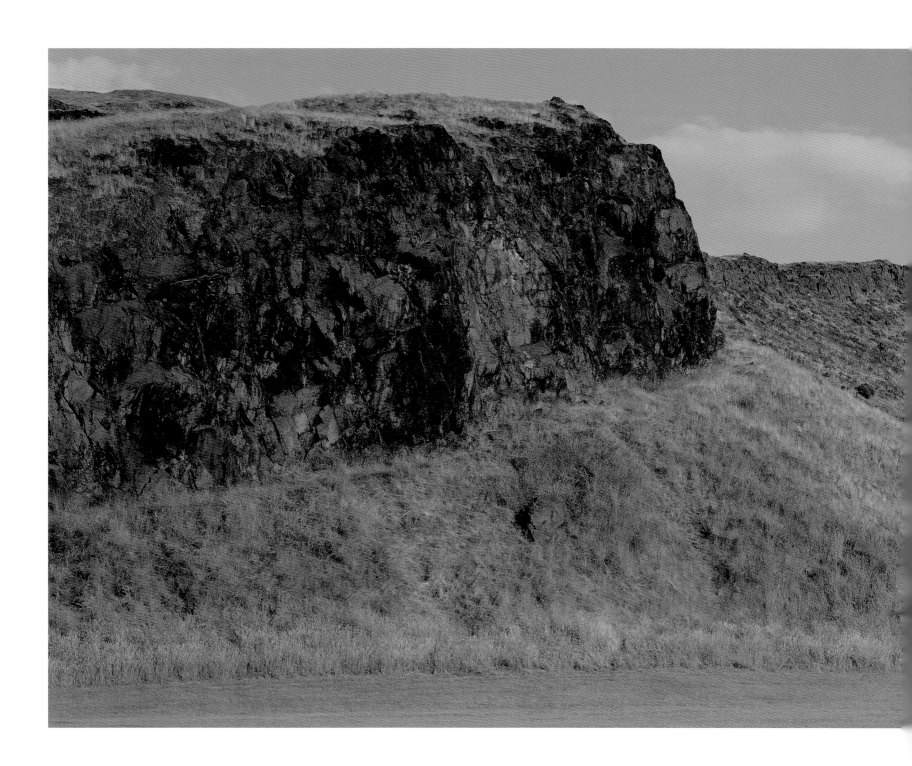

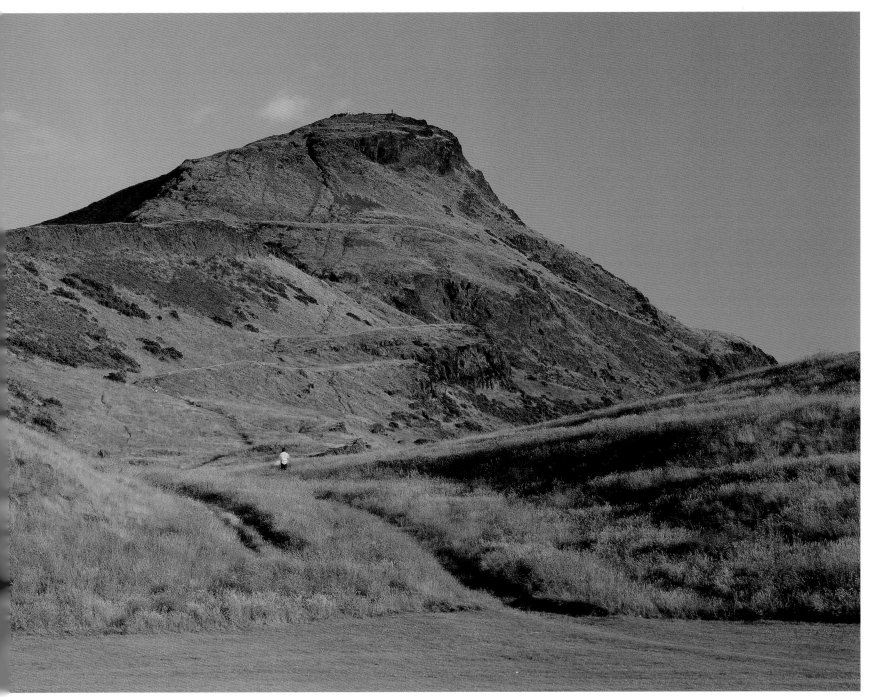

Salisbury Crags and Arthur's Seat, Holyrood Park

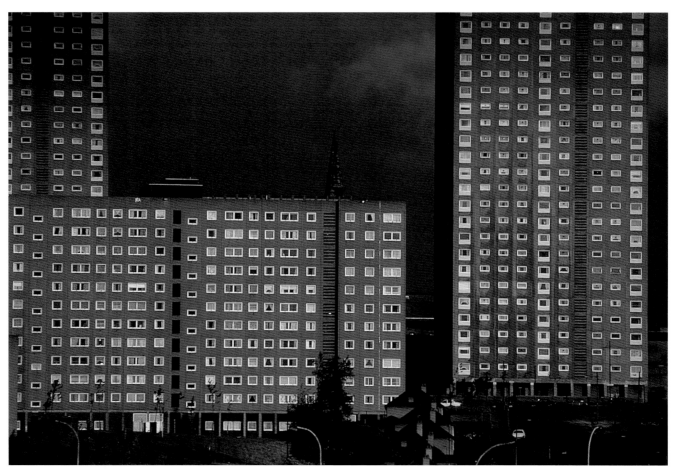

High-rise flats in the east end of Glasgow

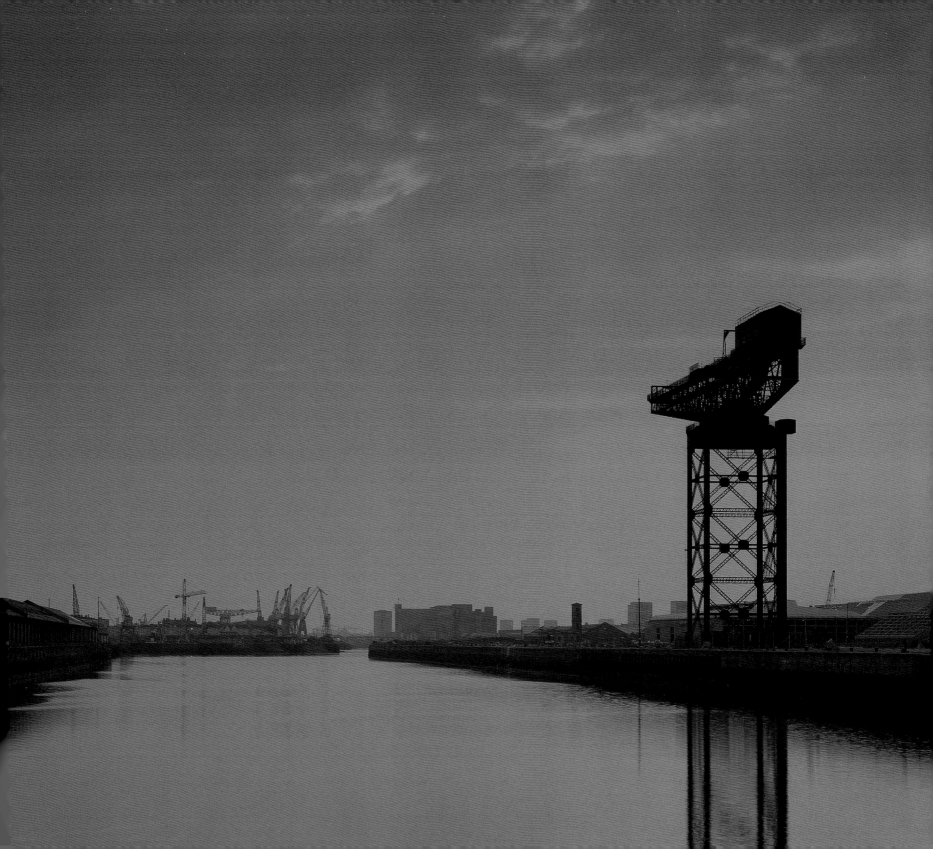

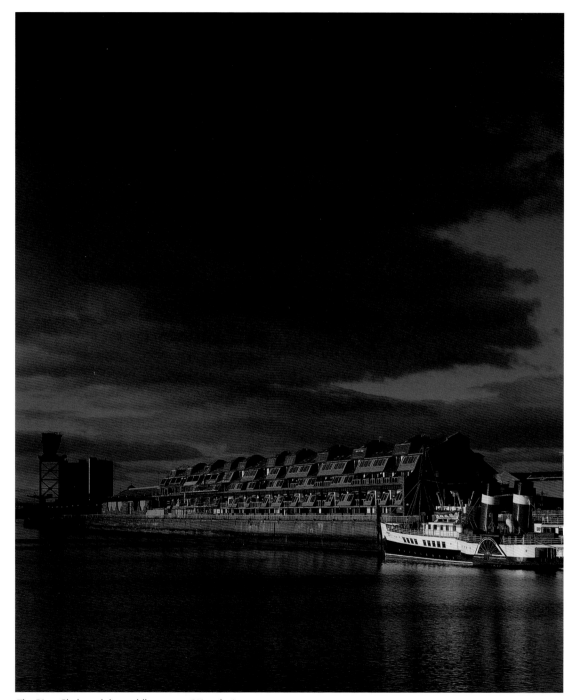

The River Clyde and the paddle-steamer 'Waverley'

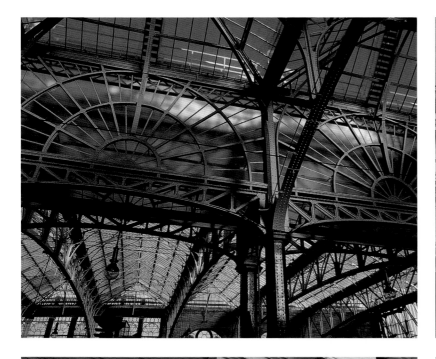

Queen Street Station
West George Street

Ingram Street
West Regent Street

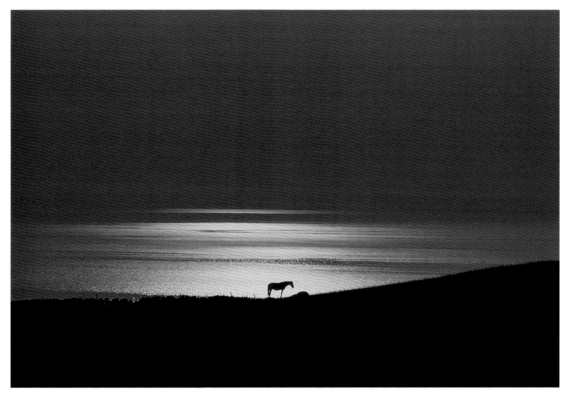

Near Macrihanish, south Kintyre

WHAT I TEND TO CALL THE SOUTHERN HIGHLANDS might irritate a map-maker or geographer. Some of Stirlingshire, most of mainland Argyll and some of west Perthshire—except where I squeeze bits of them into Glencoe and Lochaber—Islay and Jura, the islands of the Firth of Lorne, plus Colonsay and Gigha—and is Arran in the Highlands or not? (I don't know the answer to that, but sadly it's not in this book, either way.)

There is an argument for claiming that the Highlands begin where Glasgow ends (the West Highland Way, after all, starts at Milngavie) and certainly if you drive north up Loch Lomond-side the atmosphere is Highland as soon as you have put the hotels and restaurants around the southern end of the loch behind you. The island-studded water gleams through the oaks which line its banks, and across the loch rises a succession of increasingly large hills; towards the north end of the loch, Ben Lomond is, at 3194 feet, a true mountain in Scottish terms, and a Munro.

Further west Knapdale and Kintyre can hardly be described as mountainous but they are hilly, picturesque and thickly wooded: old woodland of the native Scottish species of birch and rowan, hazel and alder, as well as recent conifer-plantations. The lonely road from Inverneill round three parts of a circle to Stonefield Castle gives fine distant views of Islay and Jura, while south of the island of Gigha the views from the main coast road are positively oceanic, with nothing very much in the way between you and the Americas. Cambeltown has the feel of an outpost; the nearest larger town (and with all due respect, that's only Oban) is 87 miles away; Glasgow is 143.

Among the many inshore islands along the west coast of Argyll, Gigha, just off Kintyre, and Luing, in the Firth of Lorn, are green and fertile; cattle-rearing and dairy production are important occupations. Gigha, with its mildest of Scottish climates, has famous gardens. Luing, in fact, has its own breed of cattle ('Red Luing'), and used to be famous for its slate-production along with nearby Easdale (and Ballachulish, 50 miles further north). A little further out in the firth, the uninhabited Garvellachs have ancient but well-preserved monastic dwellings.

The prevailing characteristic of all this region is maritime. When not gazing at the vast oceanic views across the Firth of Lorn, the Sound of Jura or even the North Channel towards Northern Ireland, you will be following a twisting route around one of the many sea-lochs which penetrate further and further inland as you progress north: West Loch Tarbert (which almost cuts Kintyre in two), Lochs Caolisport, Sween and Craignish, Loch Creran whose innermost reach was recently bridged at Creagan, and Loch Etive, the archetypal fjord, which corkscrews eighteen miles into the mountains but which has never been circumnavigated by anything as mundane as a road.

On the north shores of Loch Creran lie Appin and Duror, among the most romanticised of all regions of Scotland, former stronghold of the Stewart clan, made famous once by R.L.Stevenson in *Kidnapped*, and again in recent years by the resurrected tale of the judicial murder of 'Seamus a' Ghlinne' (James of the Glens). This has been adopted almost as eagerly as the Glencoe story, as a symbol of the cruelty and repression suffered by the clans under the government-sponsored forces after the '45 rebellion. Two hundred and fifty years after the event there are still those who claim to know the secret which James took with him to the grave. Folk memory is a powerful thing.

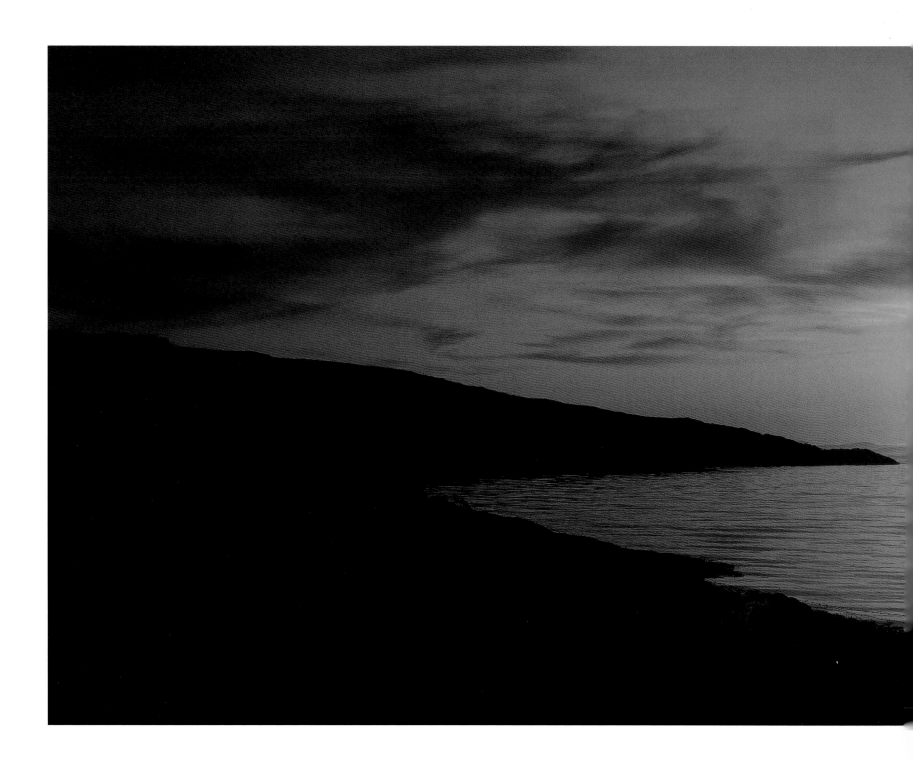

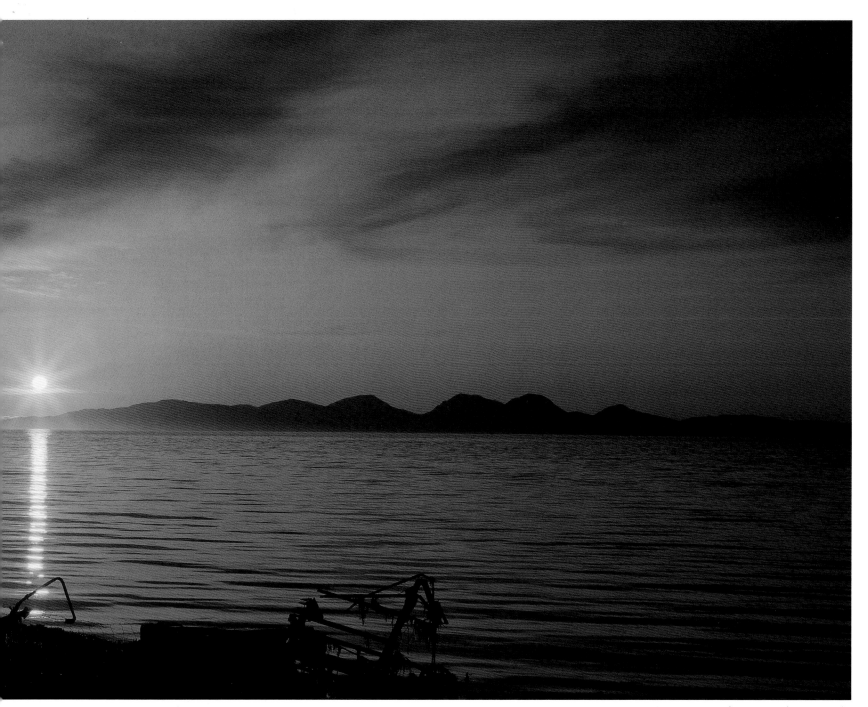

Sunset over Jura, from West Tarbert Bay, Gigha

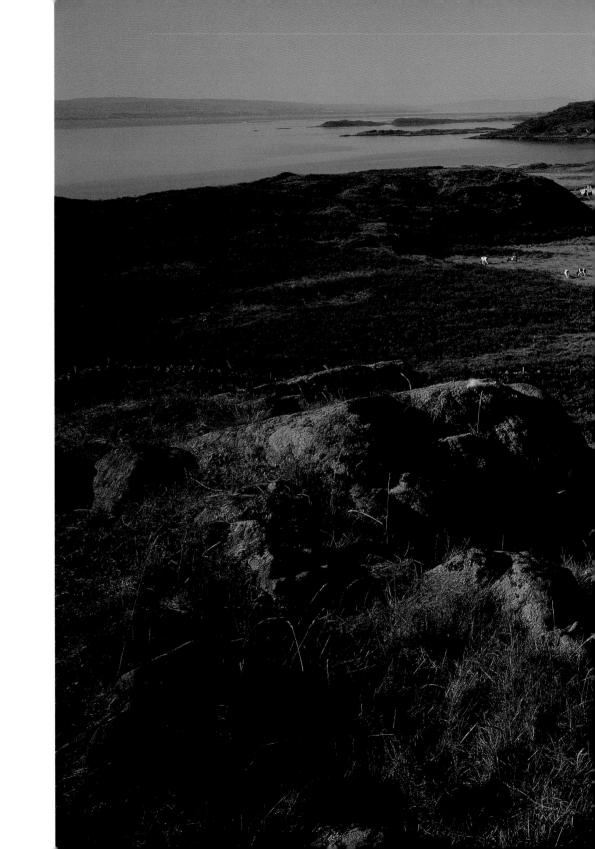

The north end of Gigha, from Creag Bhan

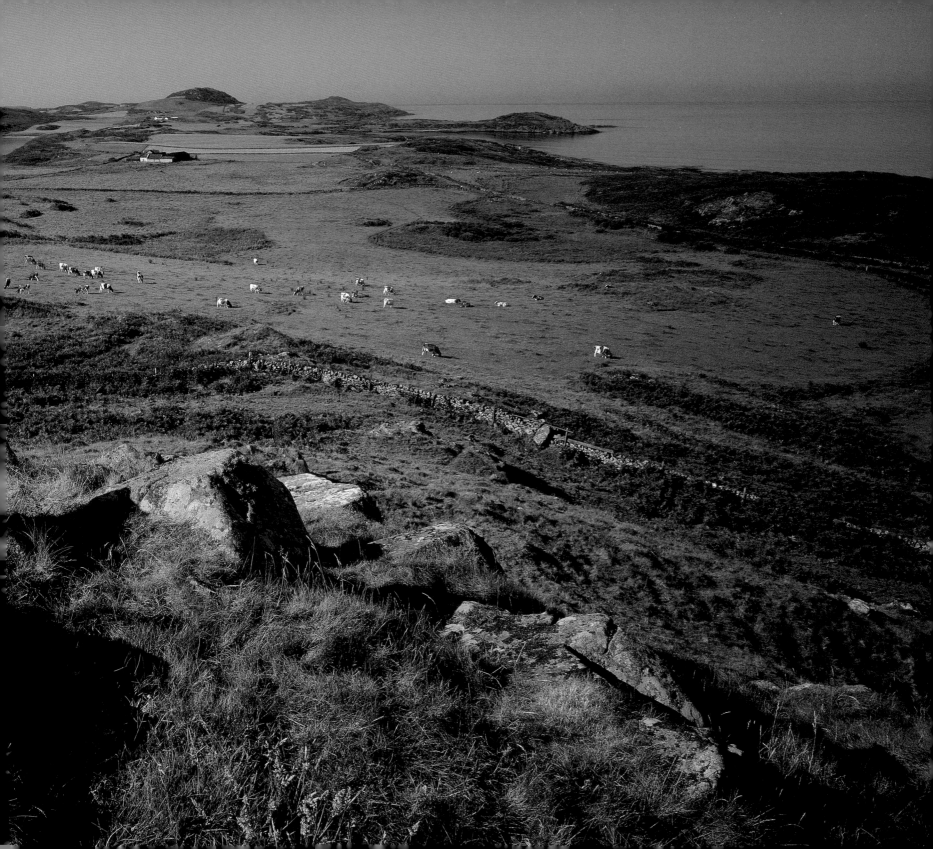

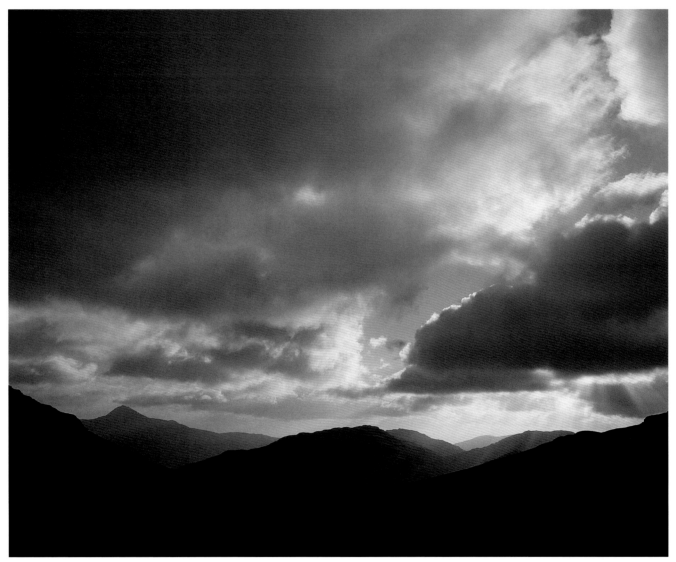

Ben Lomond from Ben Arthur (The Cobbler)

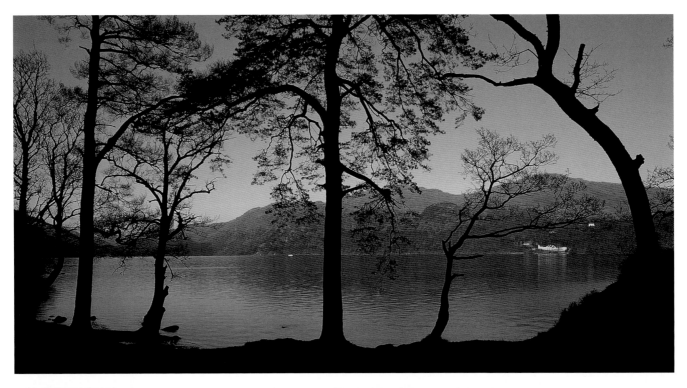

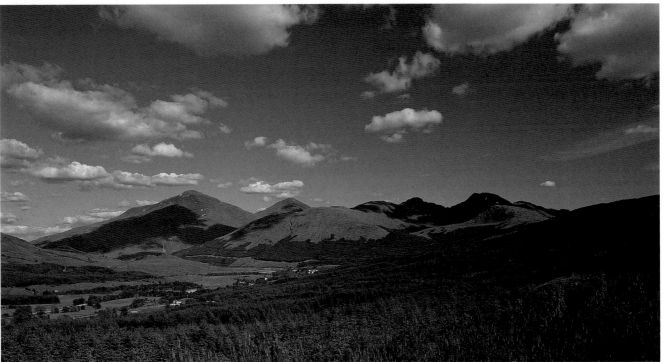

(Top) Loch Lomond at Inversnaid

(Lower) The Crianlarich Hills

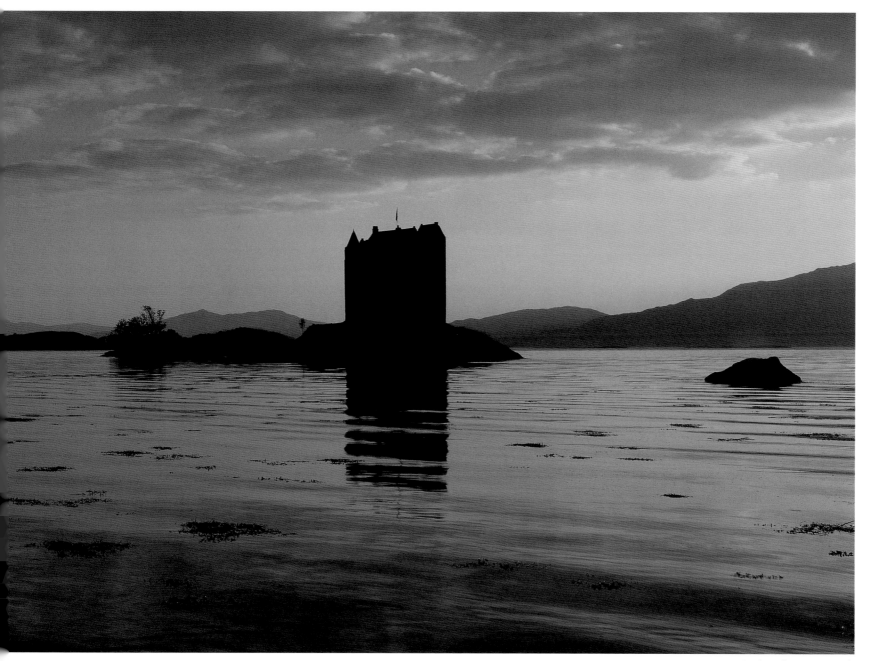

Castle Stalker, Portnacroish

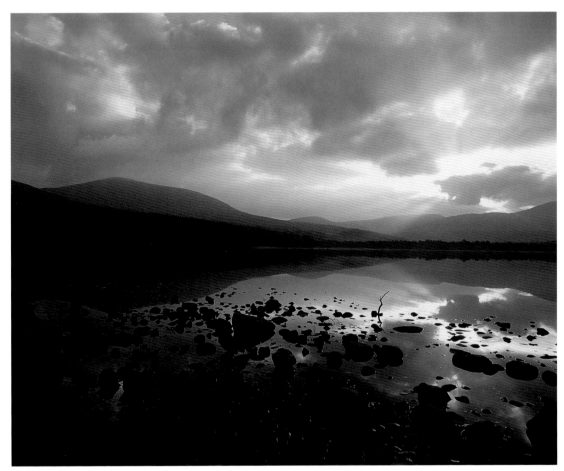

Loch Morlich, Spey Valley

THE CENTRAL HIGHLANDS LIE FAR FROM THE SEA or, at least, as far from the sea as you can get in Scotland's small and narrow landmass. The only waves here are the rising swells of the hills themselves, and especially in winter their rolling white billows have a grandeur unsurpassed anywhere in these islands.

According to many atlases, the 'Grampian Mountains' extend from Lochnagar in the eastern Cairngorms to Arrochar at the north end of Loch Long. The term is often also applied to the range of mountains which fill the great wilderness bounded by the Spey Valley in the east, Glen Spean to the south, and the Great Glen. These hills are more properly called the Monadhliath, but in any case I have never heard any Scot use the term 'Grampian'; it seems to be reserved solely for use by map-makers.

Grand hills though they are, the Monadhliath have only a few Munros along their southern fringes (though Creag Meagaidh is an exceptionally fine one) and are overshadowed in every sense by their larger cousins across the broad Spey Valley, the Northern Cairngorms. Most of Scotland's 4000-foot summits are here, and the Cairngorm plateau—a vast region lying above 3500 feet—is considered to exhibit arctic/alpine characteristics in flora, fauna and weather. A winter storm in the Cairgorms can be a savage enemy, as several unfortunate parties have found to their cost. The great amount of snowfall in a typical winter allied to the steepness of the north faces, of otherwise soft and rounded hills, also makes avalanche a constant danger, and on the plateau itself navigation in anything but fine, clear weather can be extremely difficult. I discovered this for myself, once, lost for four hours between Cairn Lochan and Ben Macdui in a sudden Mayday whiteout. Lucky for me it was May not March.

The Spey Valley and the mountains which line it, especially on its eastern flank, have become one of the great playgrounds of modern Britain. There is downhill skiing, of course, on Cairngorm itself, cross-country skiing, summer and winter climbing and hill-walking throughout the range; canoeing and kayaking, wind-surfing, parascending, hang-gliding, orienteering, mountain biking, angling, bird-watching ... this is no doubt only a partial list, and it might be tempting to think, therefore, that the region is one to avoid for much of the year if the peace and quiet of the hills is what you want. These mountains and their valleys and forests are so vast, however, that if you stay away from the obvious honeypots like the ski-slopes, Glen More Lodge and Aviemore, it's not hard to be alone in beautiful surroundings, winter or summer.

Apart from the wealth of high-quality rock- and ice-climbing in the Cairngorms, there are many fine expeditions which can be undertaken, several of which have a real sense of adventure and remoteness. One is a traverse of the range from Glen More Lodge to the Linn of Dee near Braemar, over the tops or through the famous pass, the Lairig Ghru. Another is a round of the 4000-foot tops – Cairngorm, Ben Macdui, Cairn Toul, Angel's Peak, Garbh Choire Mor, Einich Cairn and Braeriach, and I was attempting this when the blizzard caught me behind Cairn Lochan. Down in the valley everything was green when I had set off that spring day but the entire plateau was still feet deep in snow. I don't think I was ever in any real danger, either lost in that white-out or the next day, trudging in knee-deep snow, near the limits of exhaustion, up the final slopes of Braeriach. But I remember it all as a great adventure.

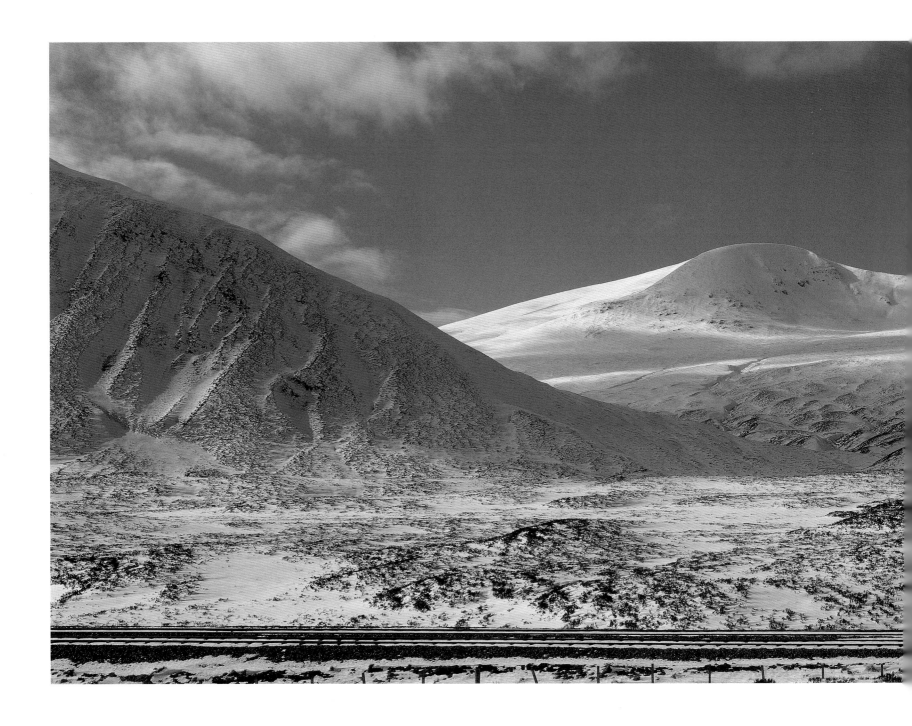

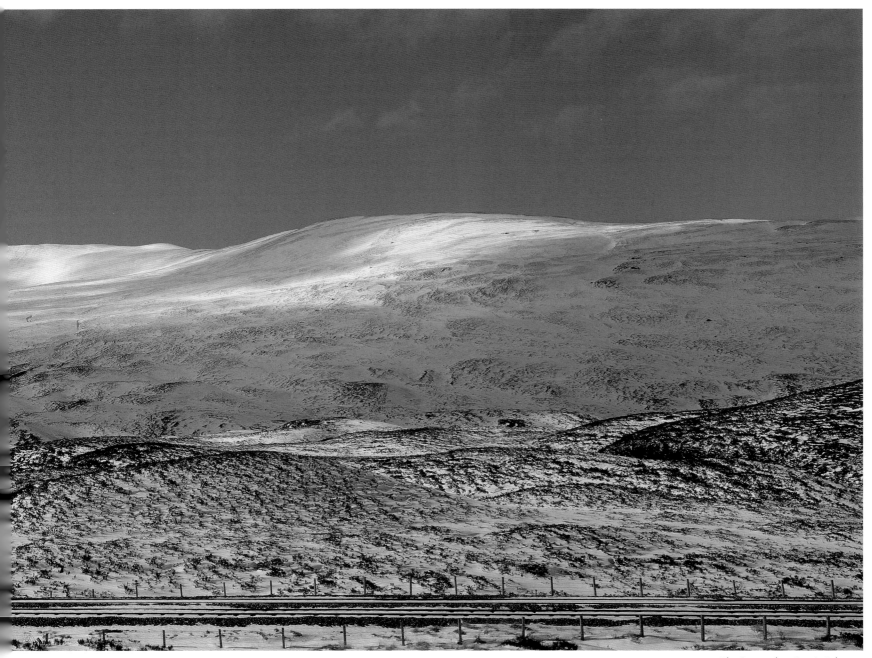

The Drumochter Pass in February

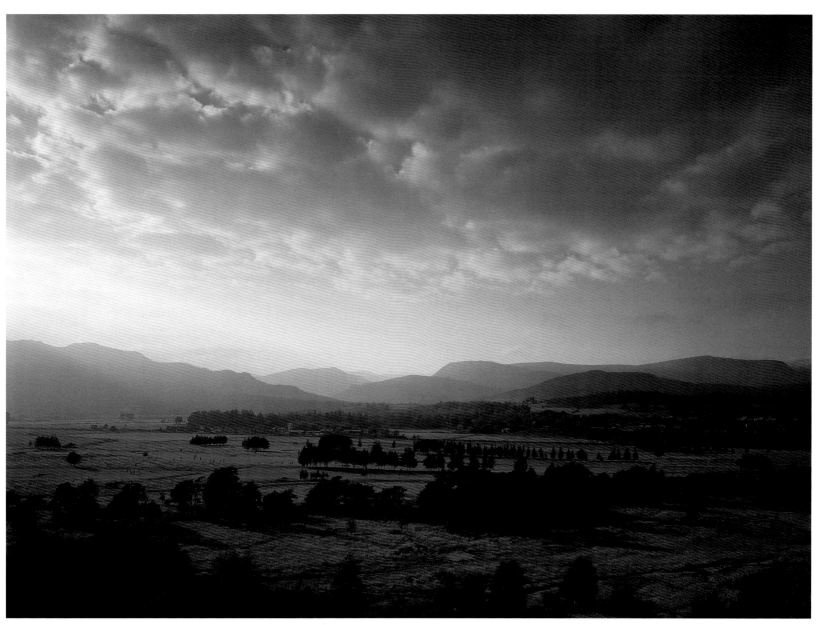

The Spey Valley at Kingussie

Loch Insh, Spey Valley, near Kincraig

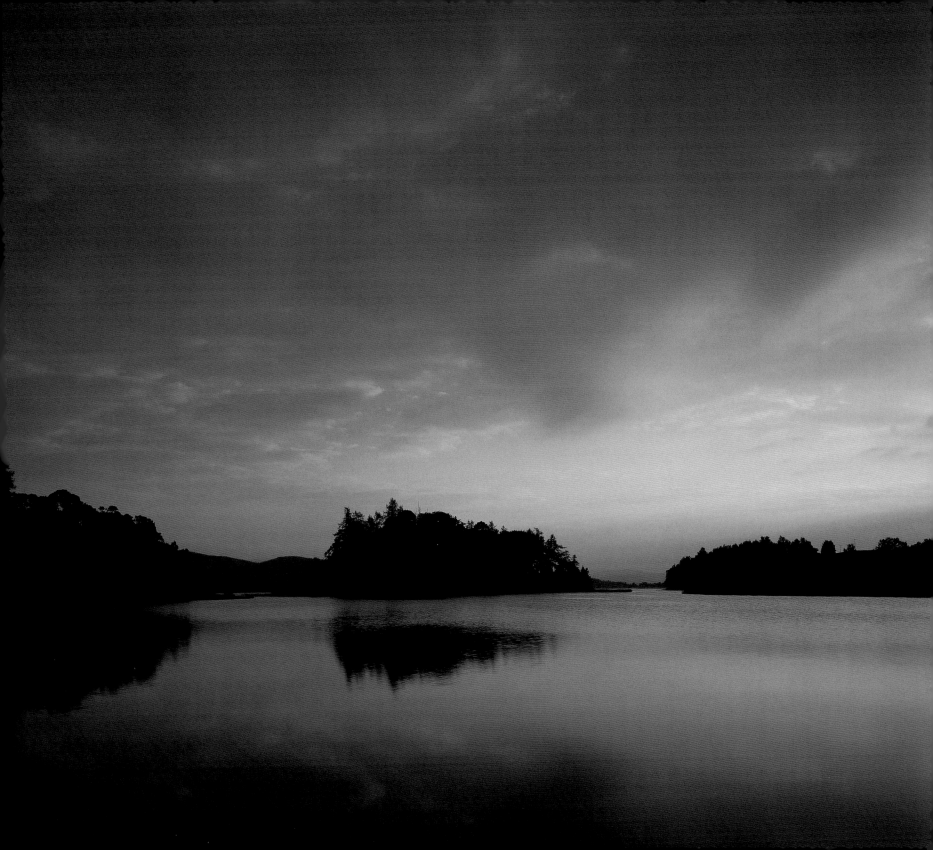

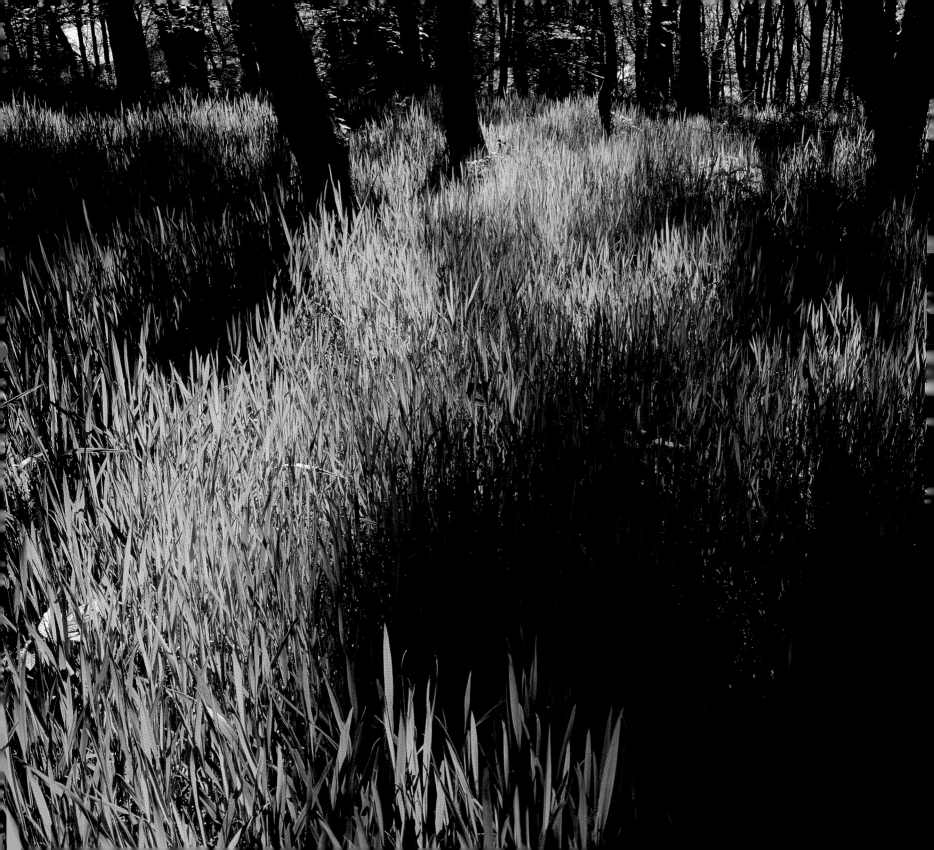

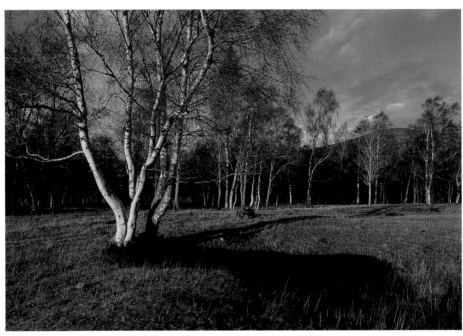

Birches near Tarland, Aberdeenshire

Woods near Errogie, Invernesshire

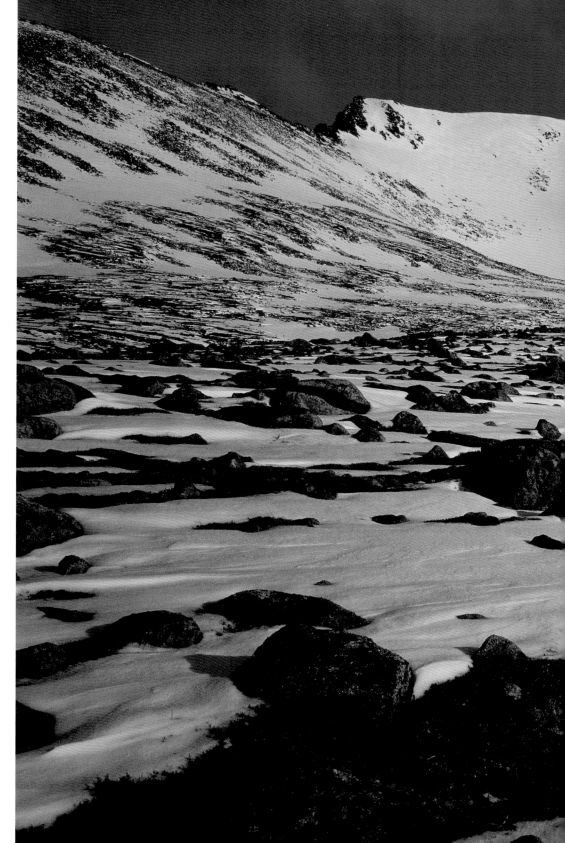

Coire nan Lochan, northern Cairgorms

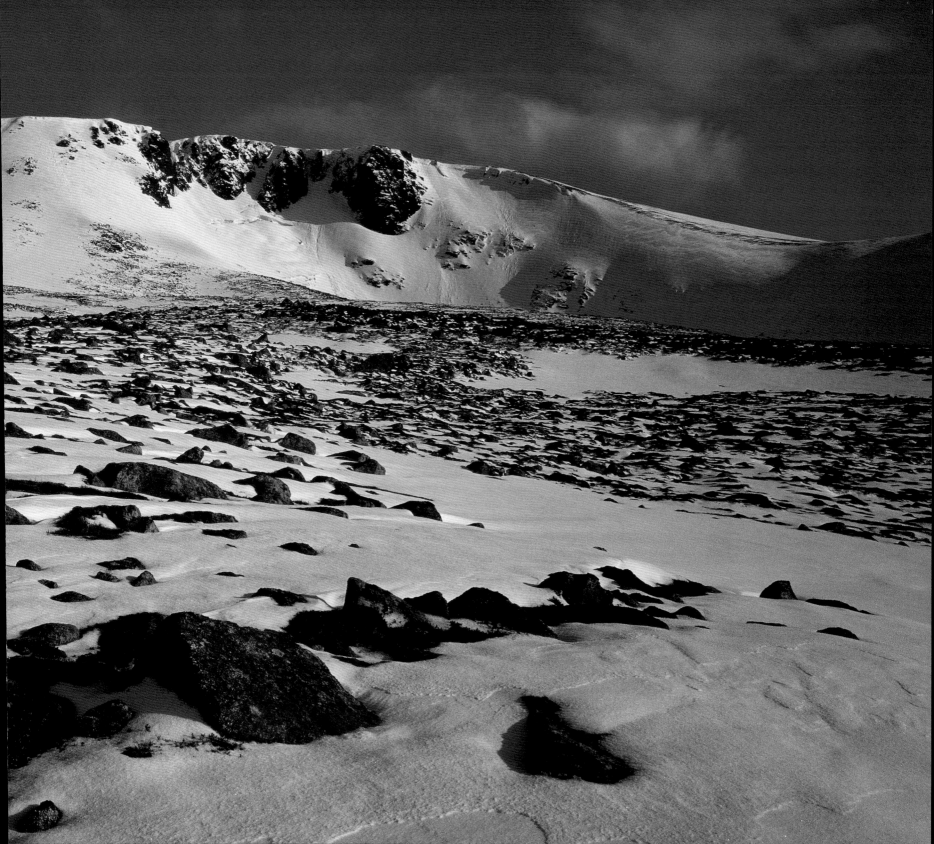

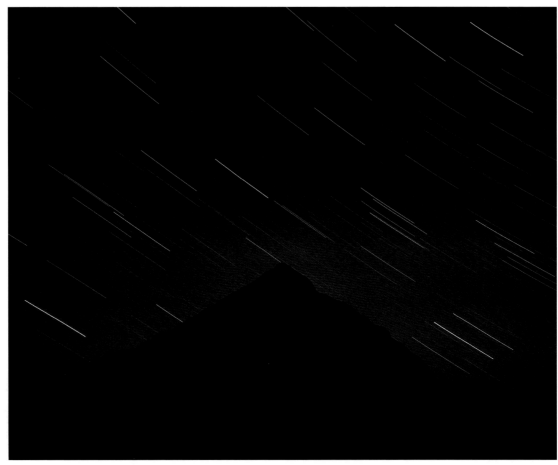

Buachaille Etive Mor, Glencoe, by night

LOCHABER, GLENCOE, GLEN ETIVE, RANNOCH MOOR –names to conjure the finest of Scottish mountain scenery. Lochaber itself contains not only Ben Nevis, Scotland's highest, but the Mamore Hills, the Aonachs, the high and remote Stob Choire Claurigh range and all that wild country along the northern and southern flanks of Loch Arkaig, from Glen Dessary to Glen Roy. Superlatives are unnecessary; the names speak for themselves.

At the southern end of the region, Rannoch Moor is traversed by the main Glasgow to Fort William road, the A82, and its accessibility has made it perhaps the most photographed landscape in the British Isles. At seven a.m. on a fine February morning the tripods are lined up along the roadside from Lochan na h'Achlaise to the River Ba, waiting for the sunrise. On such an occasion I provoke much indignation, I'm sure, by shouldering my gear and marching off into the scenery (and into everyone else's field of view) until I find myself well and truly alone. But there seems little point in making the same image as all the rest, and to be fair to myself, once out in the landscape I do my best to get behind a bump which will hide me from the other cameras.

Just along the road, literally, Buachaille Etive Mor is the single most iconic peak in the Scottish Highlands, and the scene of numerous epoch-making ascents, when the whole art and science of climbing was pushed forward.

Several of these ascents were made by parties including W.H.Murray, that best-loved of Scottish mountaineering authors. Writing in 1939, Murray stated: "Spring or autumn— for these have the greatest charm—a man might come here for a week and be alone". He was speaking of Coire Gabhail in Glencoe—Hidden Valley (or Lost Valley as it is even

sometimes called). The Gaelic means 'The Corrie of Capture', and this truly hidden cwm, high above the main valley-floor, was where the Macdonalds of Glencoe brought the animals, mainly cattle, stolen during their raids on neighbouring clans. Today if you substitute January or March for spring or autumn, you might, with exceptional luck, come to Coire Gabhail and be alone for an hour or so. But as with the crowds along the Rannoch Moor roadside, it is churlish to complain of others enjoying exactly what I so enjoy myself, the pleasures of the hills. As a route up into the heart of Glencoe's highest mountains, Hidden Valley is superb; on the other side of the glen, the Aonach Eagach ridge still gives, and always will, the finest ridge-walk on the British mainland; in winter it is nothing less than wonderful.

Around the corner from Glencoe a road less travelled curves along the shores of Loch Leven, another archetypal narrow fjord snaking deep into the mountains. On its northern shores the long ridge of Beinn na Caillich and Mam na Gualainn heralds the higher and finer mountains of the Mamore Hills, great walking country where narrow ridges swoop from peak to peak, and where, on the finest Scottish winter day's walking of my life—a flawless Sunday in February with 100% snow-cover—I met just one other climber. Sometimes things seem not to have changed too much since W.H. Murray's time, after all.

Nothing need be said about Ben Nevis, monarch of all our glens. But in the southern lee of the mountain a long narrow valley is another of those features which gets less attention than it should. I think of it as the Scottish Yosemite. High mountains rise on every hand, with many fine exposures of steep, clean rock; waterfalls crash valley-wards; pine and birch clothe the lower slopes; its name—Glen Nevis.

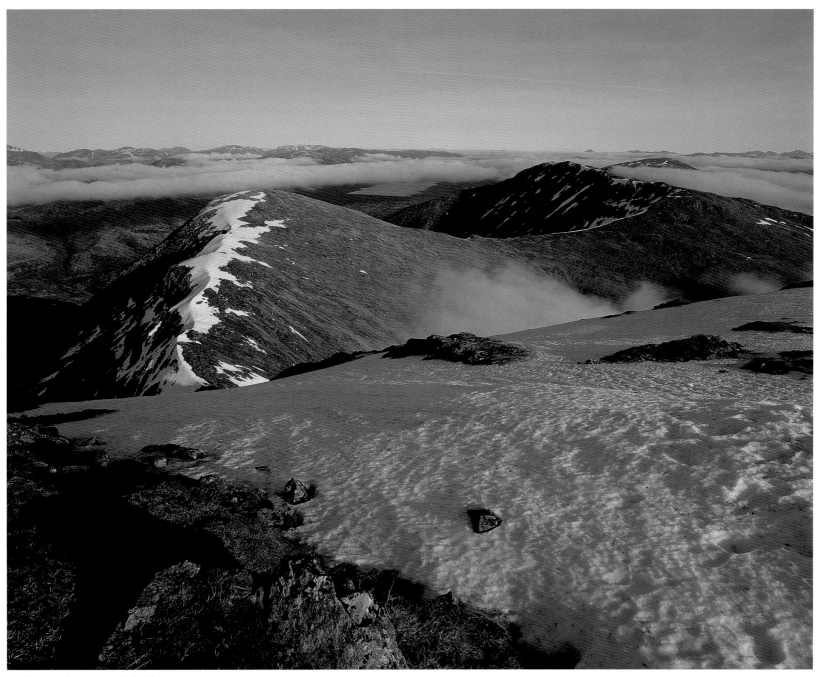

Looking east from Am Bodach, Glencoe

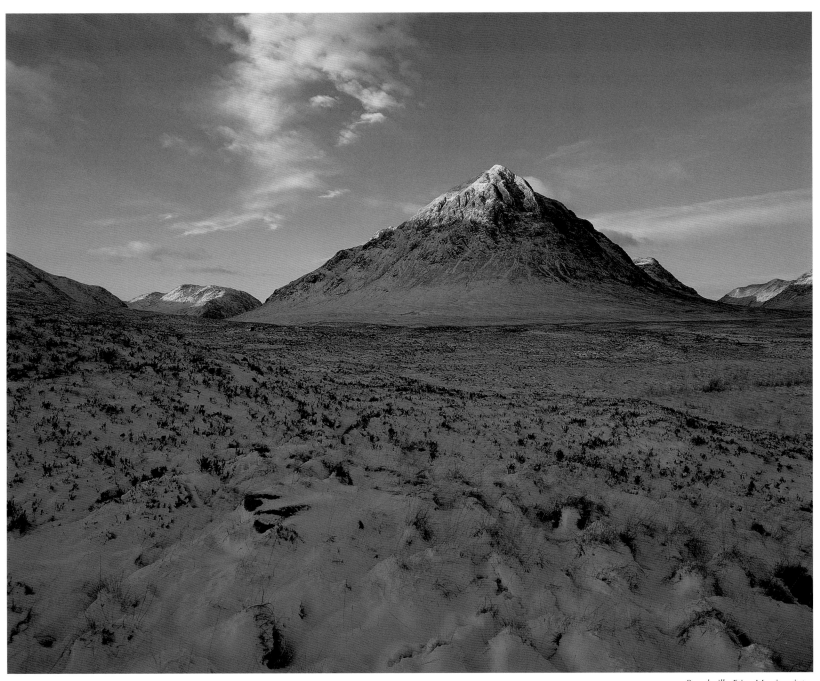

Buachaille Etive Mor in winter

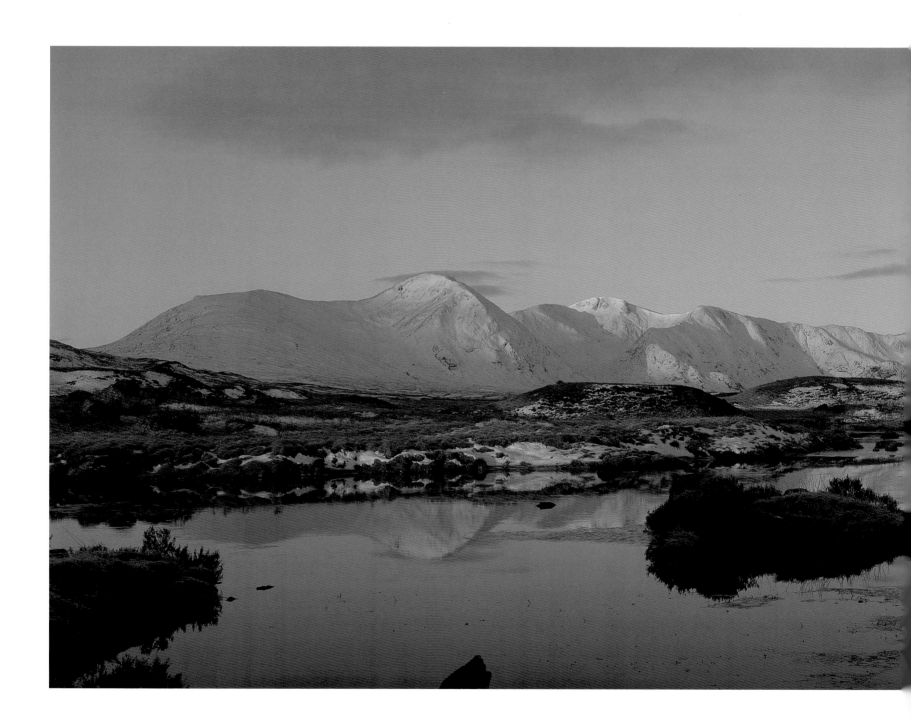

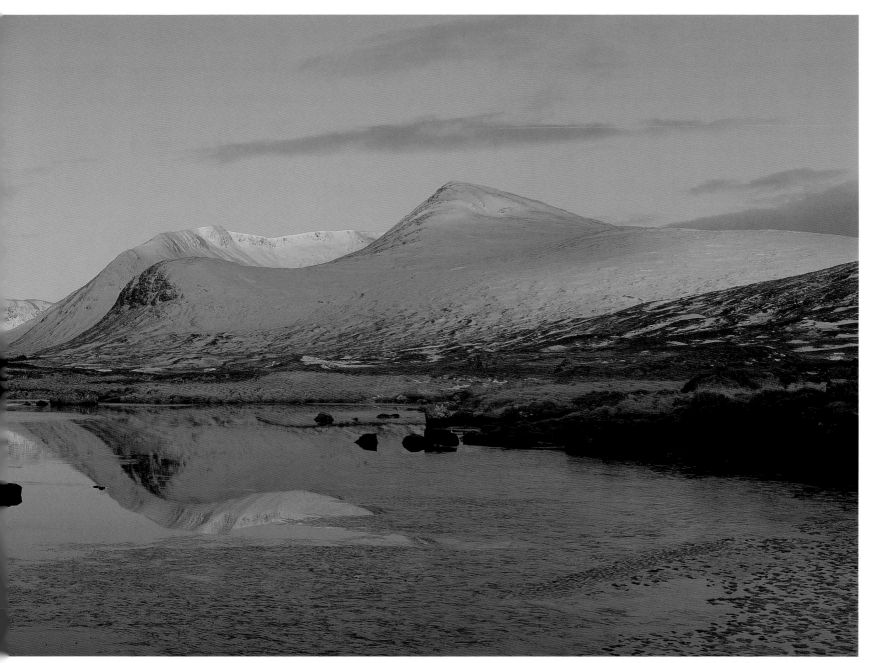

Loch na Stainge and the Clach Leathad, Rannoch Moor

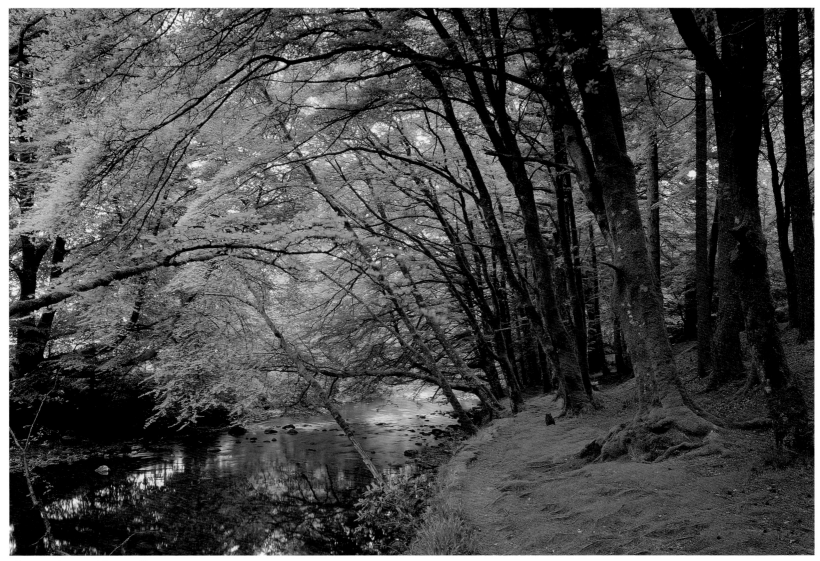

The River Coe near Glencoe village

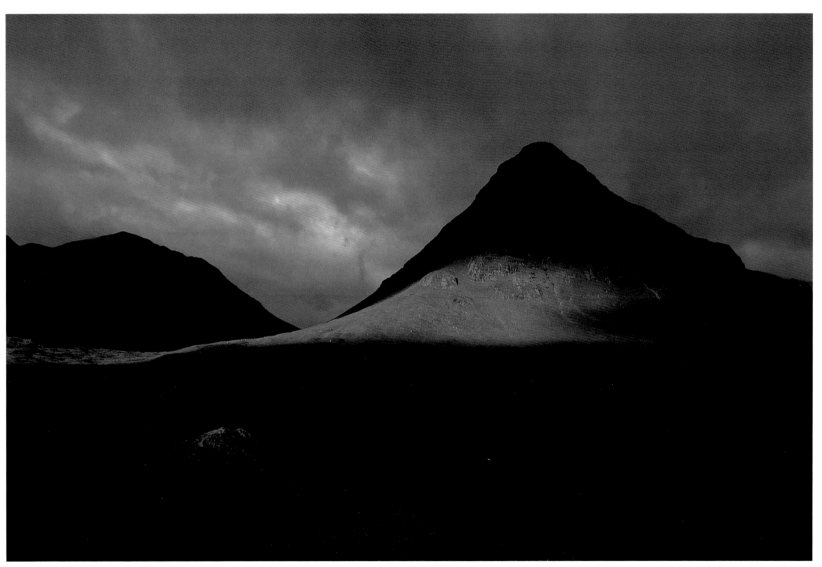

Dawn light on Buachaille Etive Beg, Glencoe

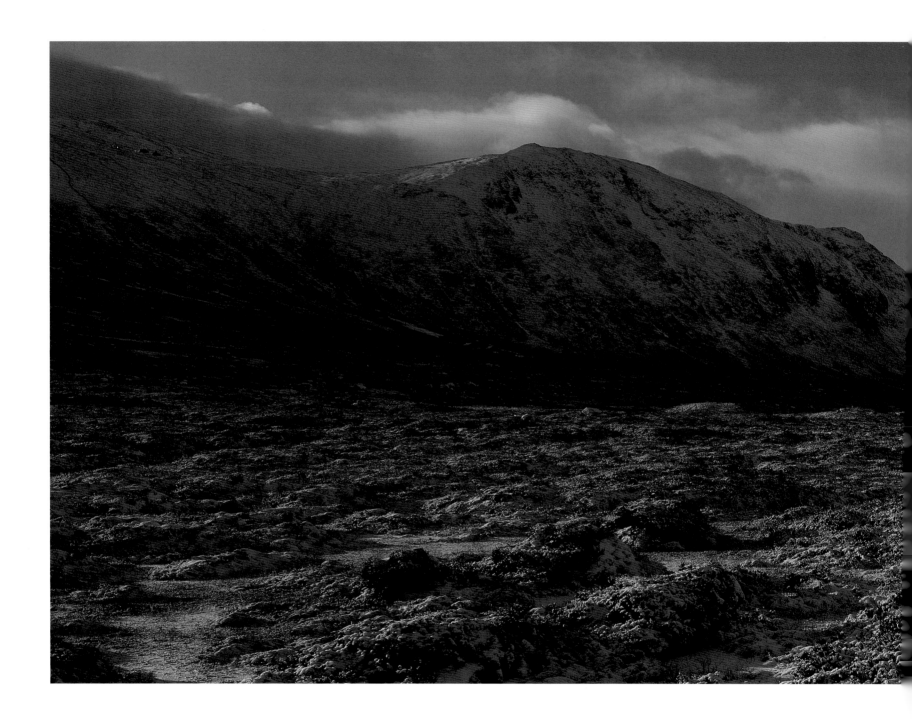

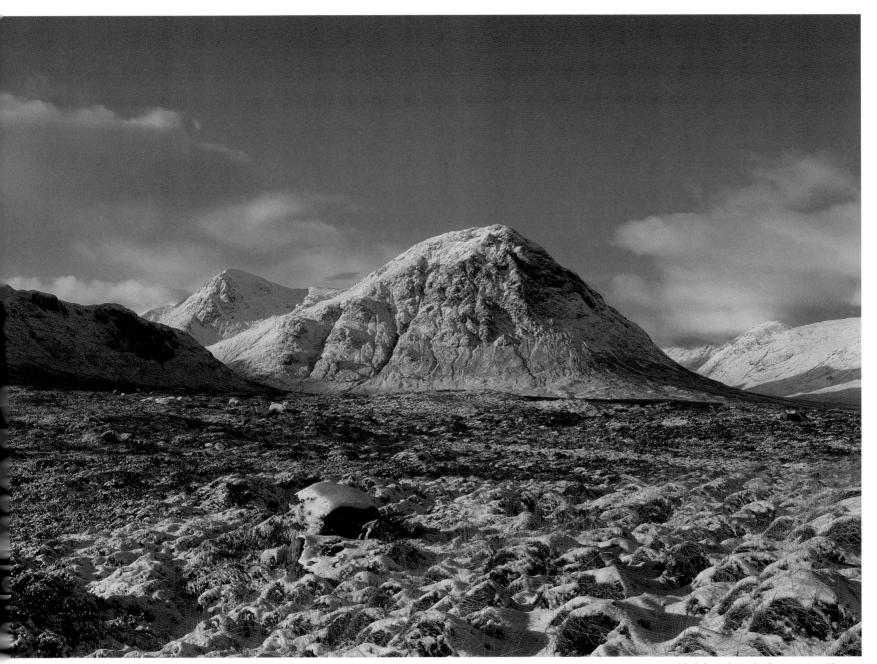

Creag Dubh (left) and Buachaille Etive Mor, Glencoe

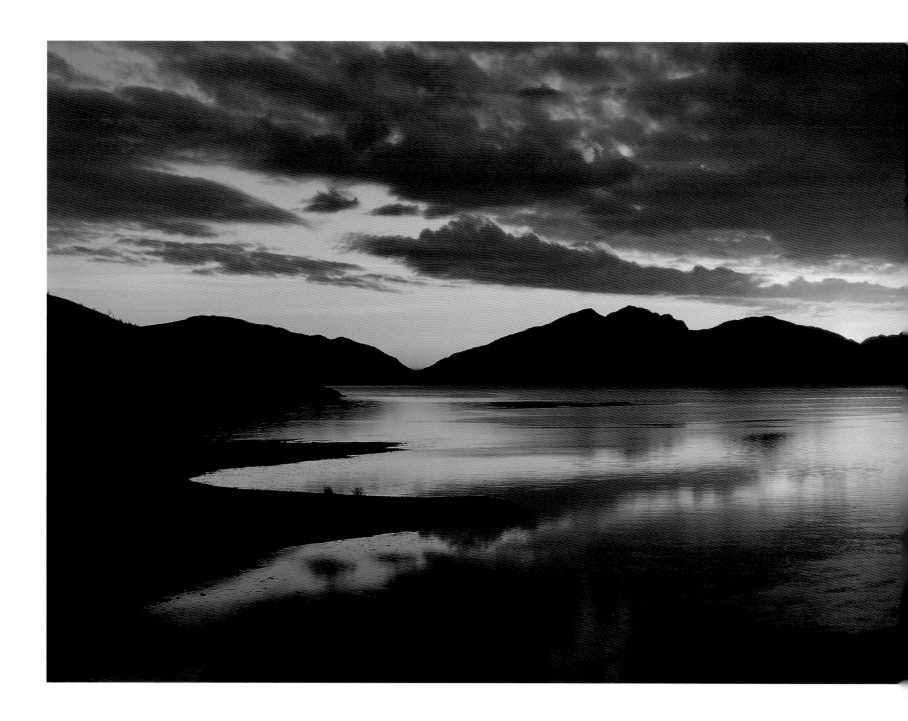

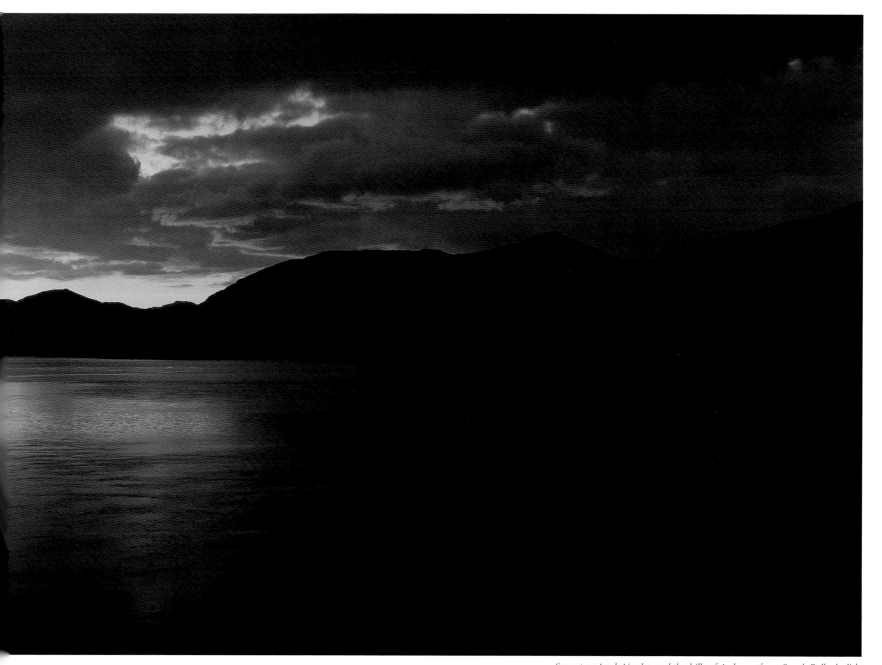

Sunset on Loch Linnhe and the hills of Ardgour, from South Ballachulish

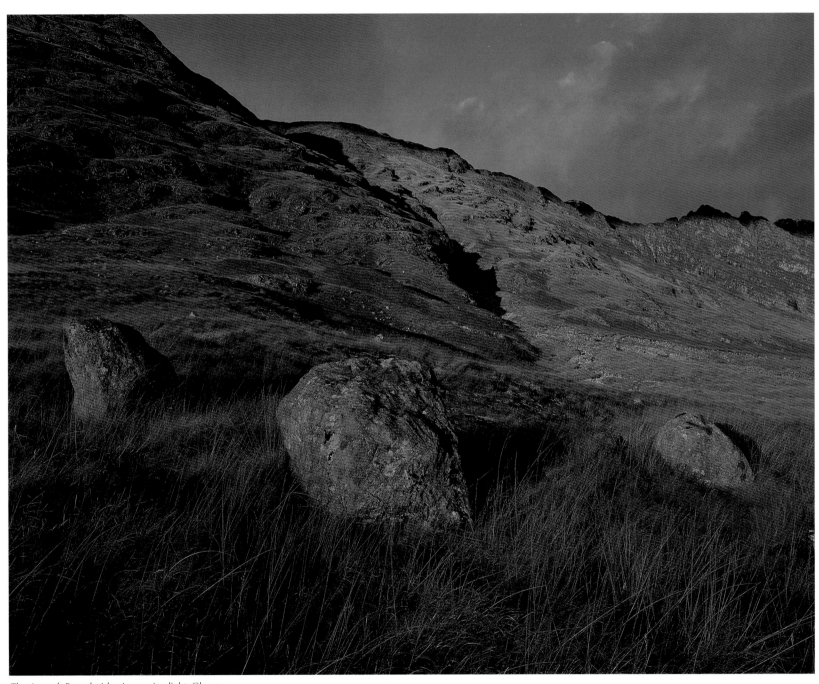

The Aonach Eagach ridge in evening light, Glencoe

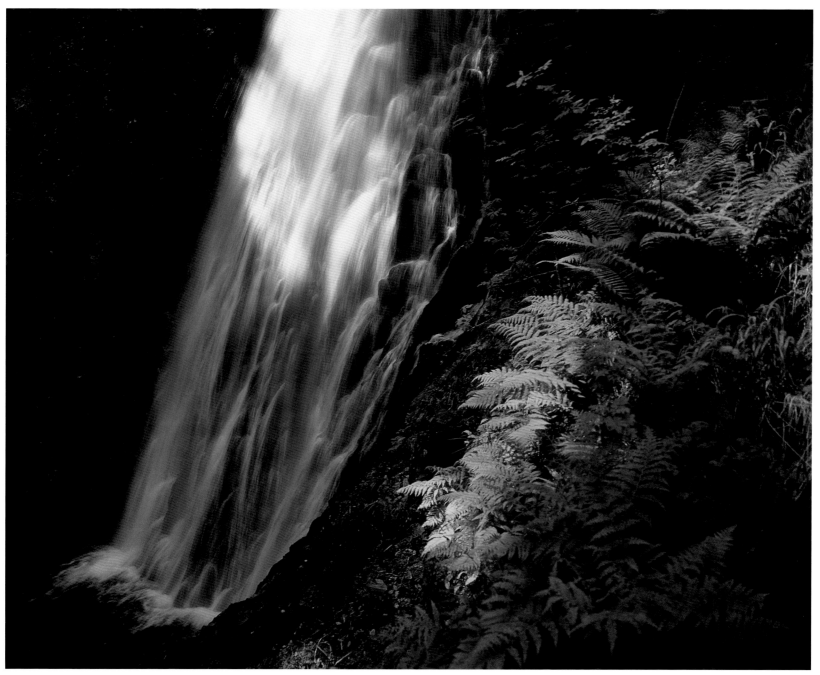

The Grey Mare's Tail, Kinlochleven

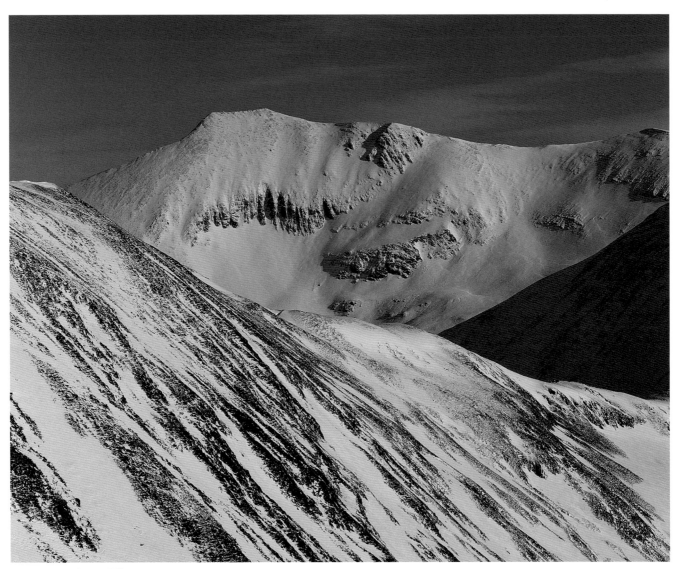

Binnein Mor, Mamore Hills

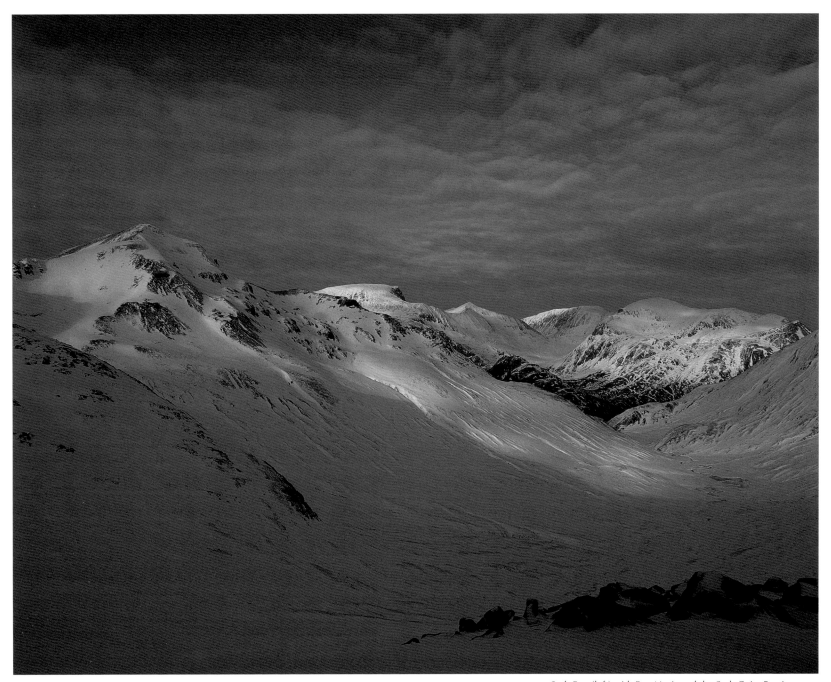

Stob Ban (left) with Ben Nevis and the Stob Coire Easain group

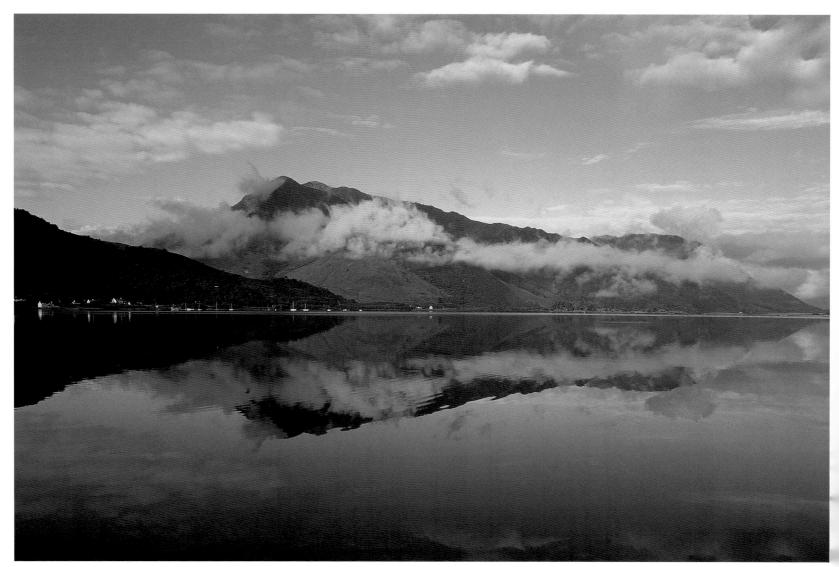

Loch Leven from Invercoe, with Beinn a' Bheithir and the north Ballachulish hills; Part I.

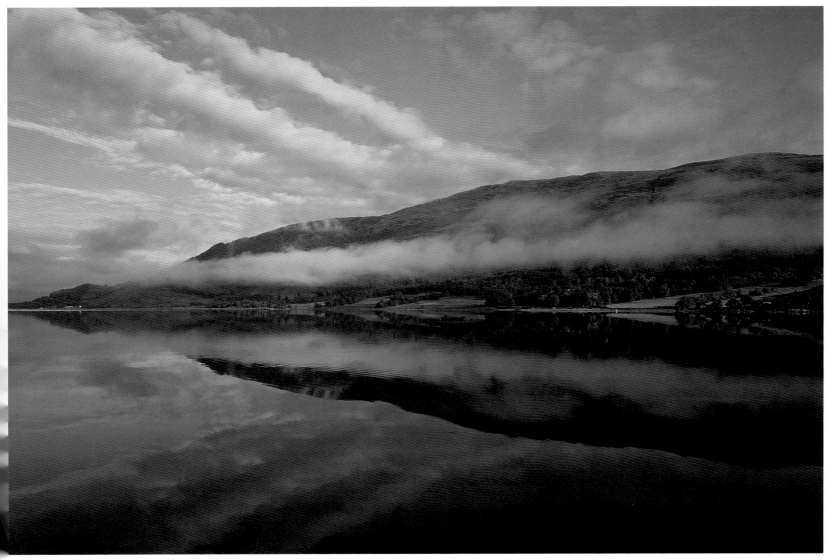

Loch Leven and the Ballachulish hills; Part II.

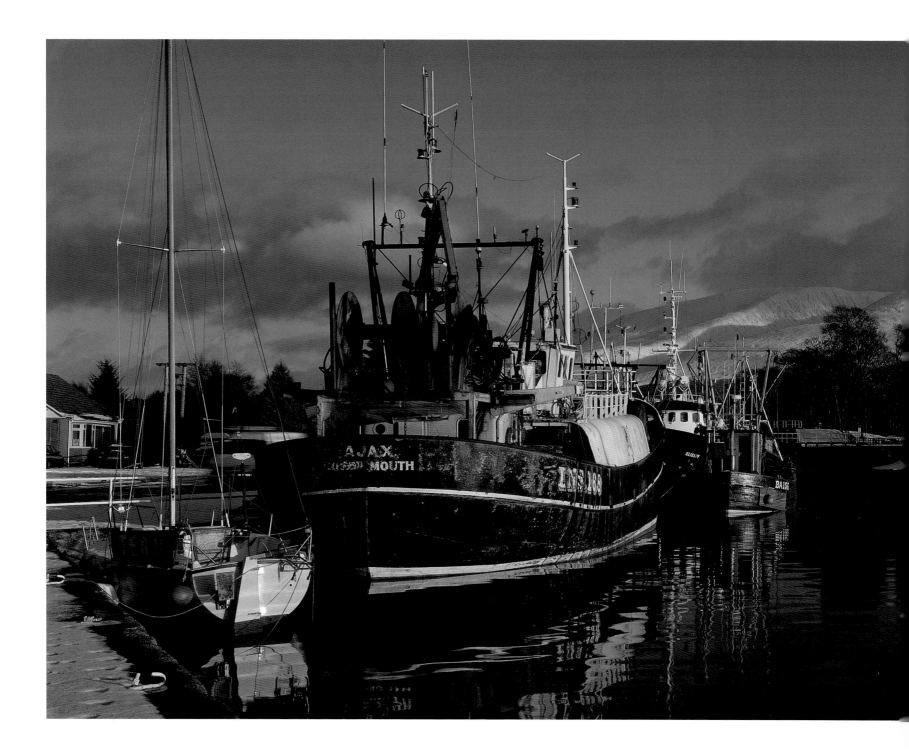

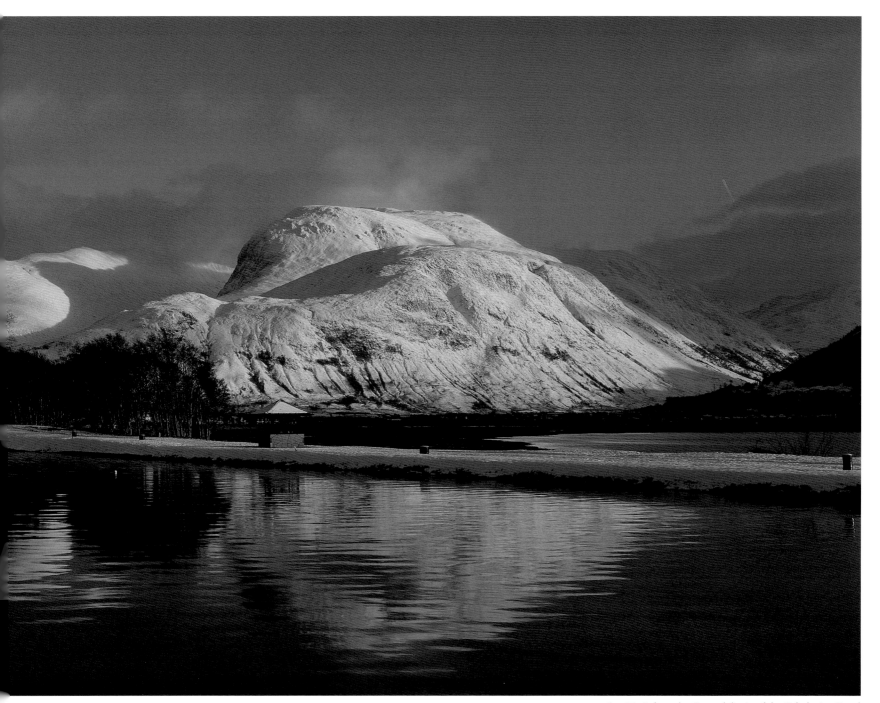

Ben Nevis from the Corpach basin of the Caledonian Canal

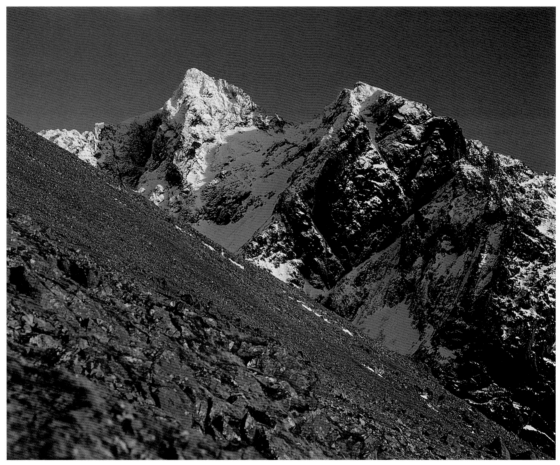

Sgurr Alasdair and Sgurr Sgumain, Coulins

THE INNER HEBRIDES ARE NOT AN ARCHIPELAGO but rather a series of archipelagos and large single islands strewn along our western seaboard from Kintyre to Torridon. The southernmost islands have been included in the section on the Southern Highlands; north of Skye and Raasay there are still, here and there, scattered islands but they are small, inshore and usually uninhabited. We will concentrate here on the main groupings.

When whole books have been devoted to single aspects of individual islands, it may seem arrogant to dispose of the entire panoply of the Inner Hebrides in a dozen pages. But to return to the notion of favourites, I don't so much dispose of them, I hope, as offer a taste of their infinite charms, with great affection. Because I do love the islands.

The islands have a special atmosphere, part of which they hold in common, as islands, and part of which is unique to each. The two largest by far—Skye and Mull—could not be more different in their personalities, and when on Mull I can never forget what I once was told—that the (beautiful) old Gaelic name for the island was 'Mull of the trees'. Though Skye of course has trees here and there, it could never, by any stretch of imagination, have been 'Skye of the trees'. Skye of the high black crags, perhaps; Skye of the peaks. Or as the genius of Gaelic language and poetry, and native of nearby Raasay, Sorley MacLean had it, Skye of the "serrated blue ramparts". There are very few areas on the island from which some part of the Cuillins is not visible, and in mid-winter when the sun skims low along the southern horizon, the mountains seem to throw almost the entire northern half of the island into daylong shadow.

Raasay has an other-worldly feel, as if it were still 1956, say, or 1962; anyway, time there stopped or at least slowed down many years ago. The island has a past which was tragic in many respects, and over a very long period; perhaps it needs that time to recover. It was savagely emptied of its people during the Clearances and today only the west side of the island is inhabited. On the lonely east coast facing the Scottish mainland, the stark ruins of a former Macleod stronghold, Brochel Castle, guard little except the tumbled stones of Hallaig and Screapadal, cleared villages made famous by the poetry of Sorley MacLean.

All the 'Small Isles', Rum, Eigg, Muck and Canna were also cleared; only two shepherds and their families were left on Rum which had nurtured five hundred people (and is not really all that small, as Scottish islands go). After decades as the plaything of a super-rich Edwardian family, the Bulloughs, who strongly discouraged all visitors except their own guests, Rum became the plaything of Scottish Natural Heritage, who continued to discourage visitors. The island is still not all that easy to visit for more than half a day, and there is a suspicion that if SNH wanted us to visit them there, they would make it a lot simpler.

In winter Mull, too, can have that lost-in-time quality, especially the remote-feeling west coast. In summer visitors flock to the island thanks to the proximity of Oban and the ease of travel by car-ferry. The island's capital, Tobermory—off-season a quiet and retiring little town—becomes a mini-Blackpool (or perhaps Brighton), its colourful high street a succession of hotels, souvenir shops and fish restaurants, thronged with visitors from all over Europe on the hunt for an unlikely bargain.

Off the south-west corner of Mull, Iona used to be other-worldly in a quite different sense. I hope it still is.

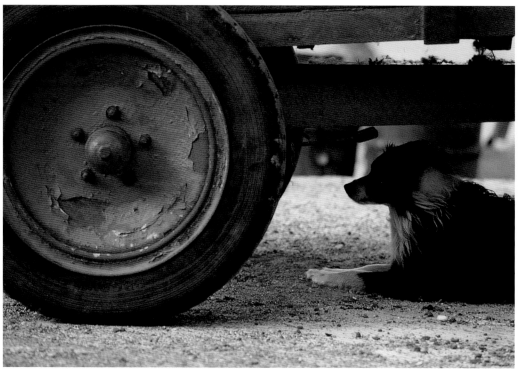

Collie dog, Iona

The Treshnish Isles from Rubha nan Oirean, Mull

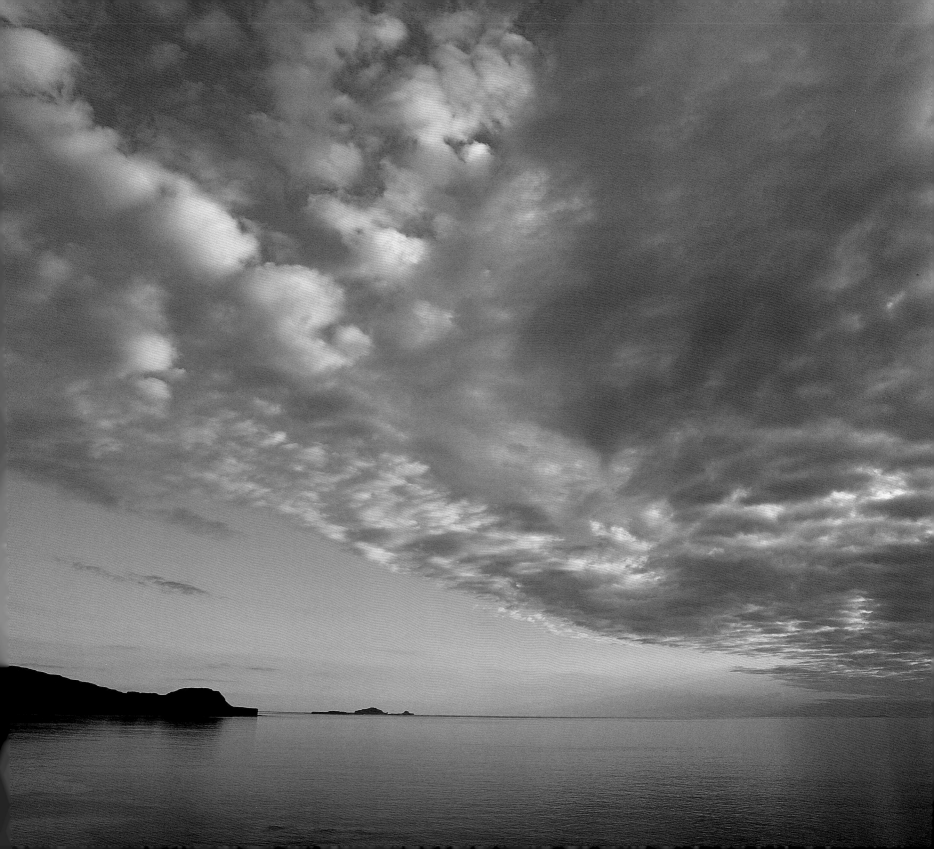

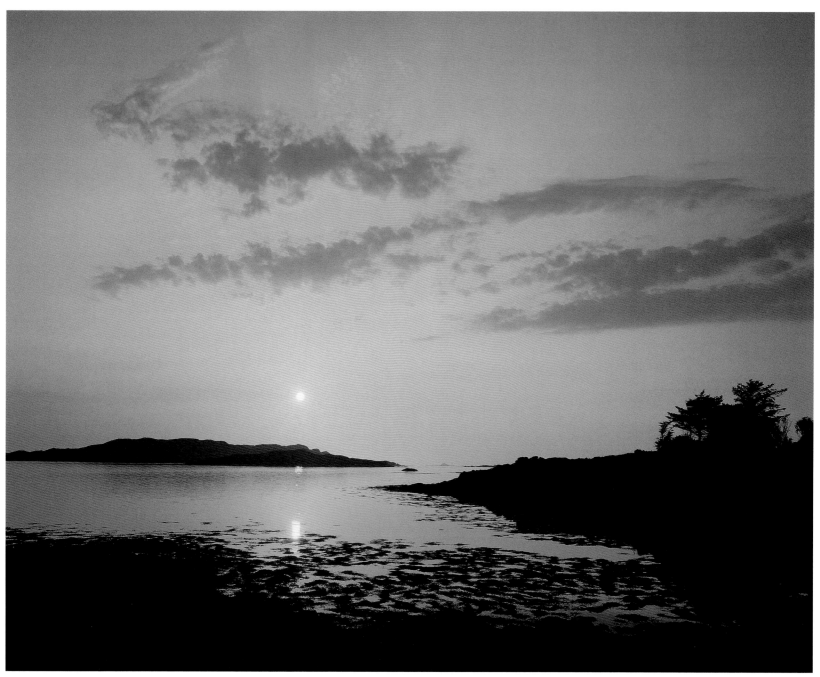

Sunset at Bunessan, Isle of Mull

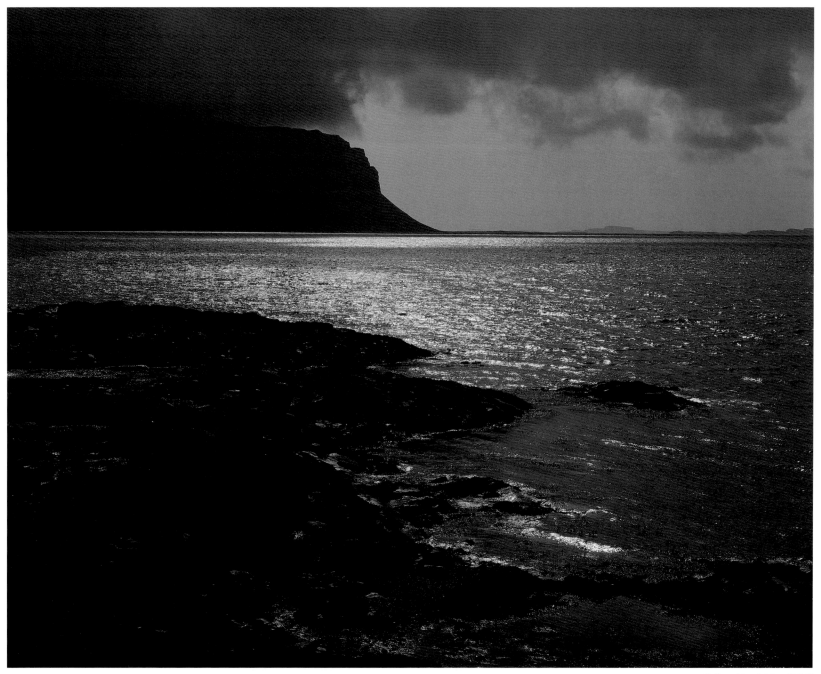

Gribun Head, Isle of Mull

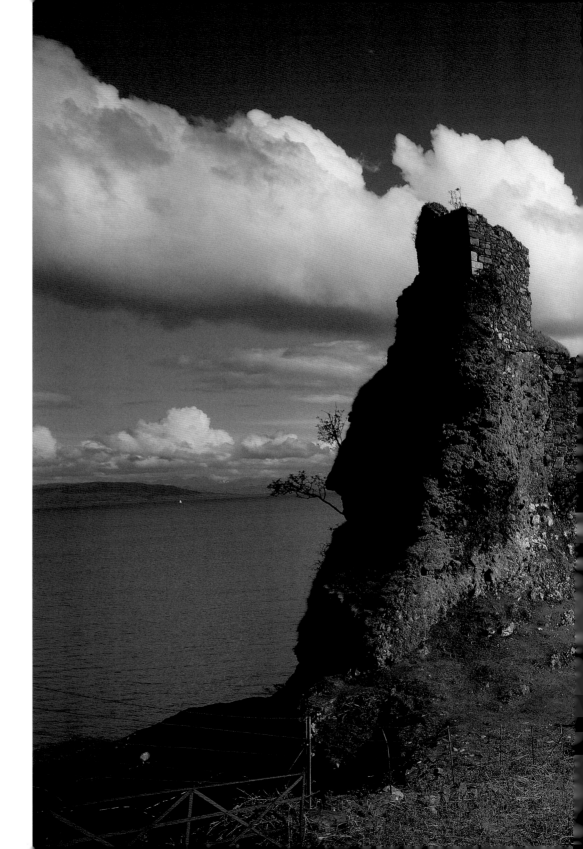

Brochel Castle, Isle of Raasay

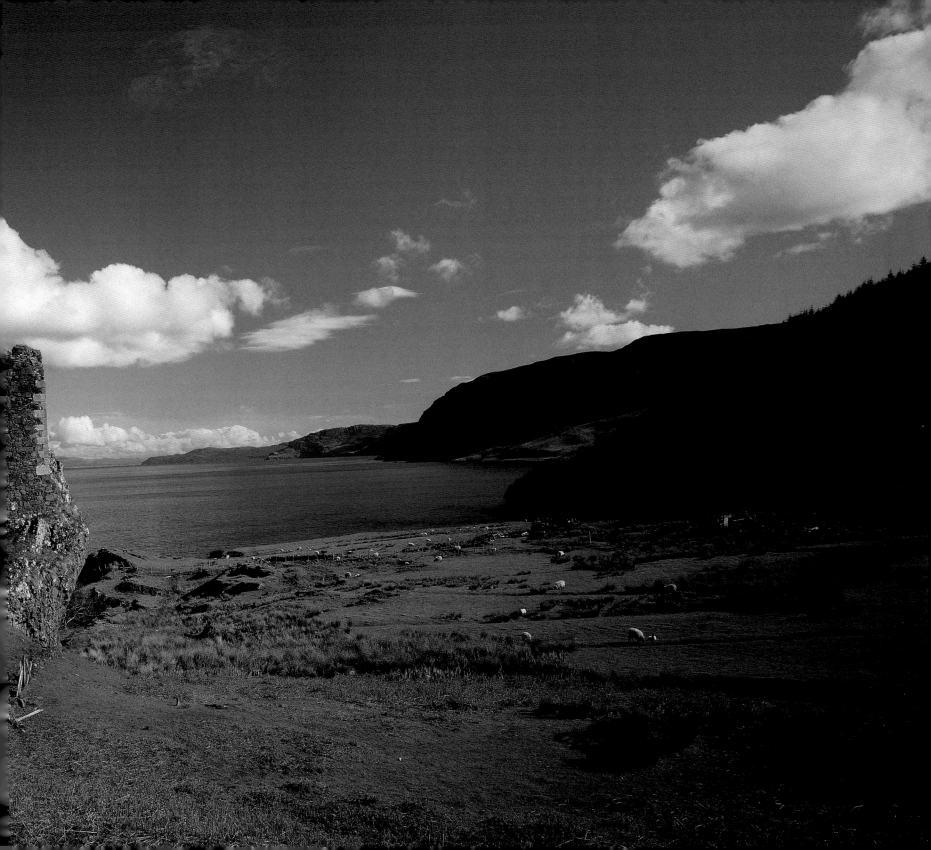

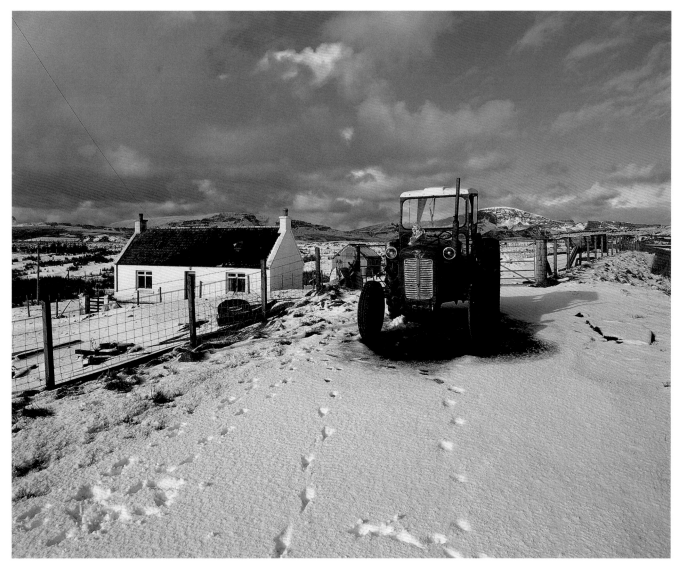

Cottage at Valtos, Trotternish, Isle of Skye

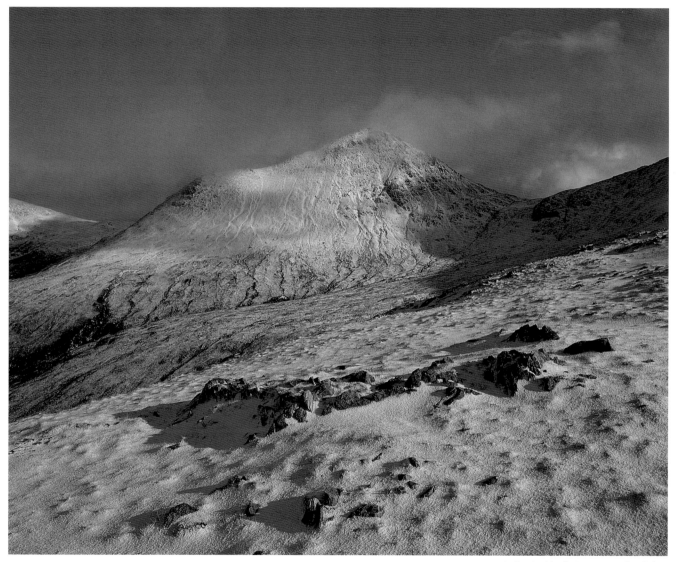

Belig, Garbh Bheinn range, Isle of Skye

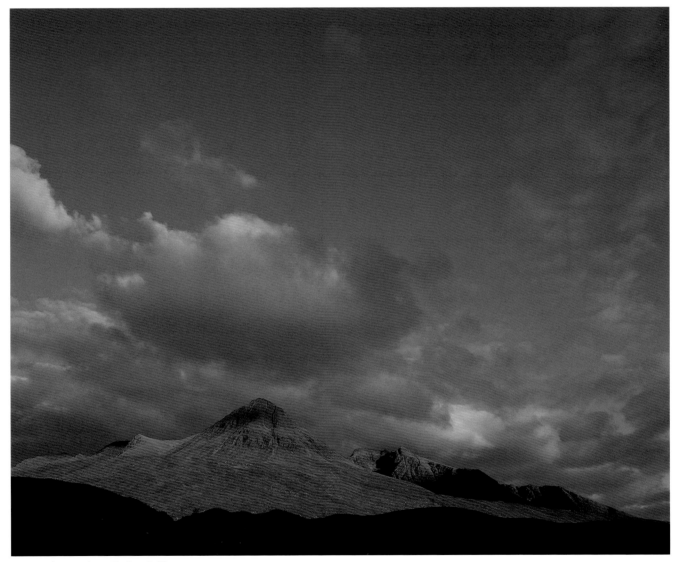

Evening sky over Sgurr Thuilm, Cuillins

The Coulins of Rum

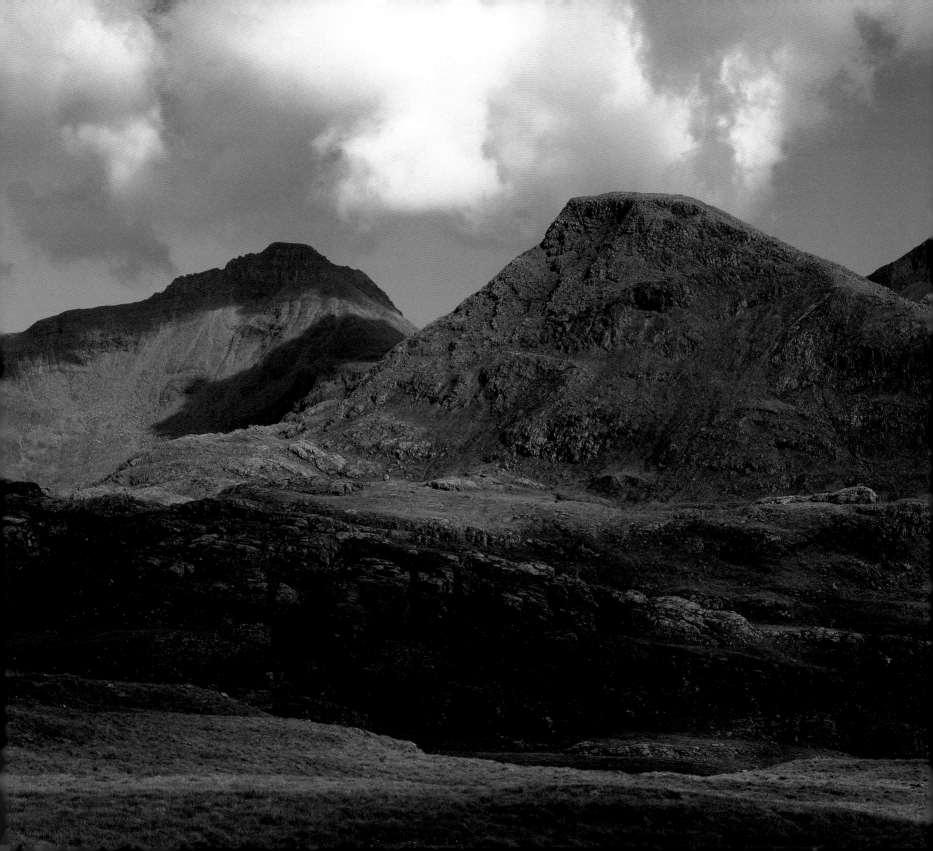

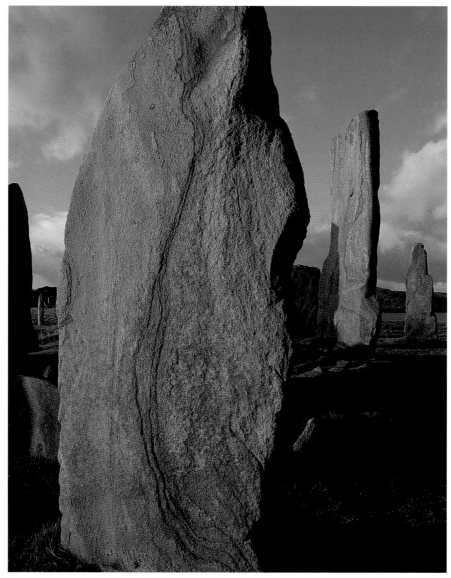

The Callanish stone circle, Isle of Lewis

THE OUTER HEBRIDES, CALLED THE LONG ISLAND, are not so much other-worldly as existing in a parallel universe. Scotland seems (and is) a long way away, and older people, especially, may speak of it almost as a foreign country. Gaelic is the language you hear most often, but complete strangers will greet you, in English for your benefit, in the most friendly way; virtually every driver on the quiet roads will give you a wave, and if you need to ask a favour of someone, nothing is ever too much trouble. In many ways it reminds me of village life during my childhood in the 1950s, in that less hurried world.

In the southern half of these islands—Barra and Vatersay, the Uists and Benbecula—the overwhelming visual impressions are of limitless sea and sky. Cloud-scapes are glorious; water is everywhere, and when the sea (rarely) is not in sight, myriad lochs and lochans mirror an ever-changing sky. Along the west coasts pristine white-sand beaches are backed by the famous machair which provides a narrow fertile strip, cultivated in some places but mostly left as succulent, clover-rich pasture for cattle and sheep. The islands have a rocky spine, and hills rise to fair heights in the centres of most of them. From Vatersay to North Uist the ancient Norse names roll off the tongue –Heishaval and Heaval, Easaval, Layaval, Stulaval and Sheaval, Hecla, Eaval and Marrival.

The east coast of these islands is quite different from the west; rocky and rough, deeply riven by fjords, coves, sea-lochs and bays of every conceivable size and shape; the map shows a fretwork of lochs, inlets and islands of unbelievable intricacy.

In this complex, strung-out archipelago communications are important, and in recent times there have been useful developments. Not long ago, to take a car the eight miles from North Uist to Harris it was necessary to sail thirty or so miles to Uig in northern Skye followed by a similar journey from Uig to Tarbert in Harris. Today a new ferry makes the short trip across the Sound of Harris from Otternish to Leverburgh; elsewhere new causeways link the islands of Vatersay, Eriskay and Berneray to Barra and South and North Uist respectively.

These improvements may do little to change the seemingly languid and unhurried lifestyle here, but in fact they have almost overnight reversed the drift away from some of the smaller isles, where life was close to becoming untenable. The ability to commute directly to work on the larger islands was all it took to make places like Berneray viable again; people are moving back; house-building is in full swing where once the commonest sight was of mouldering, abandoned croft-houses.

The northern half of The Long Island comprises Lewis and Harris, with the much smaller inshore islands of Taransay, Scalpay and Great Bernera. Only the latter two are inhabited, though Taransay gained great notoriety as the site of the tv series 'Castaway', where a number of ill-suited, ill-assorted city-types were thrown together to make a 'life' together for a year on the 'desert' island.

Harris is a beautiful place whose features follow the pattern of the Uists, with stunning beaches and lush machair in the west, a spine of steep, rough hills and a rocky, labyrinthine east coast. Lewis, whose largely empty interior is one vast heather moorland, has a superb coastline, interesting hills in its westernmost region and a dramatic northern finale at the Butt of Lewis, where ceaseless Atlantic rollers crash at the base of black, 500-foot cliffs.

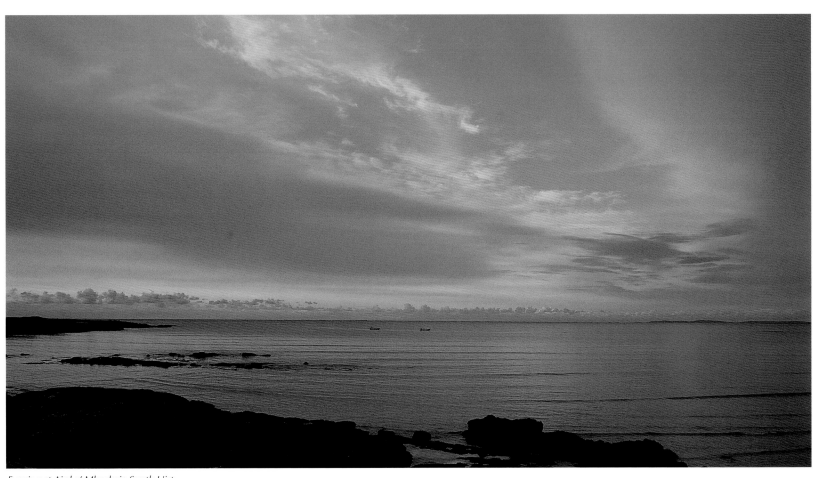

Evening at Aird a' Mhachair, South Uist

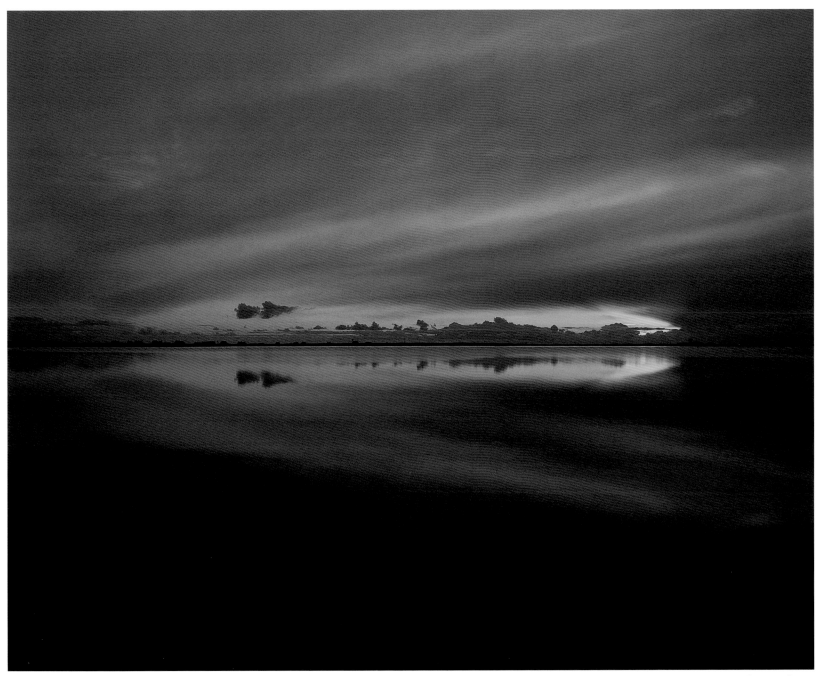

Sunset over Loch Bi, South Uist

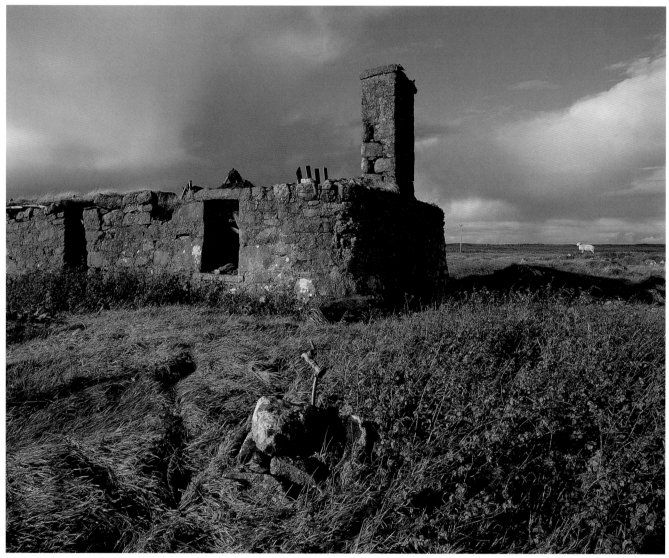

House at Kilpheder, South Uist

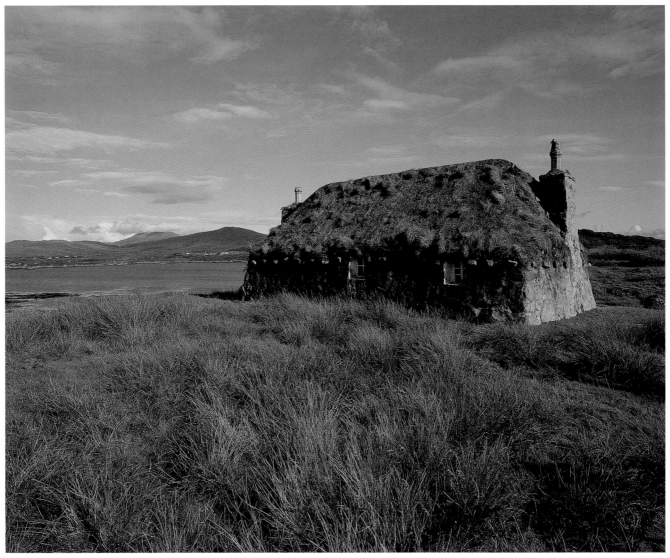

House at South Lochboisdale, South Uist

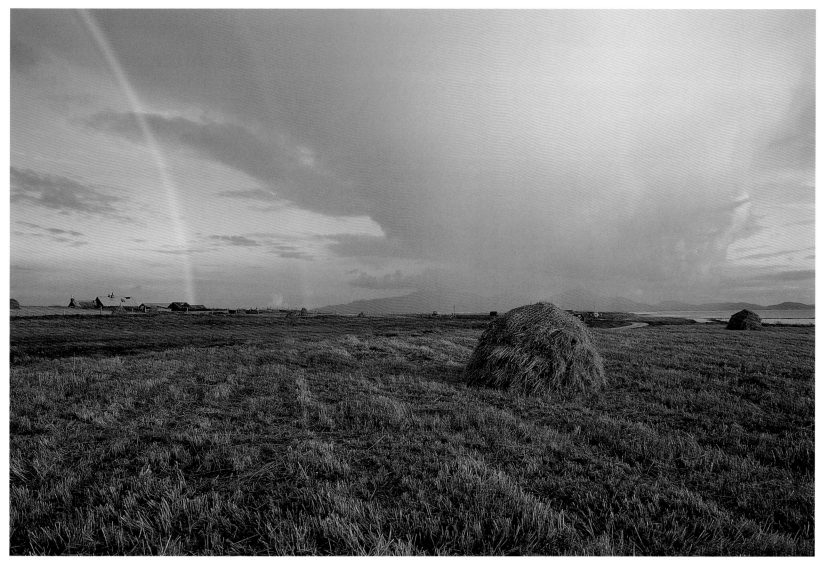

Rainbow at Aird a' Mhachair, South Uist

The Outer Hebrides seen from Duntulm, northern Skye

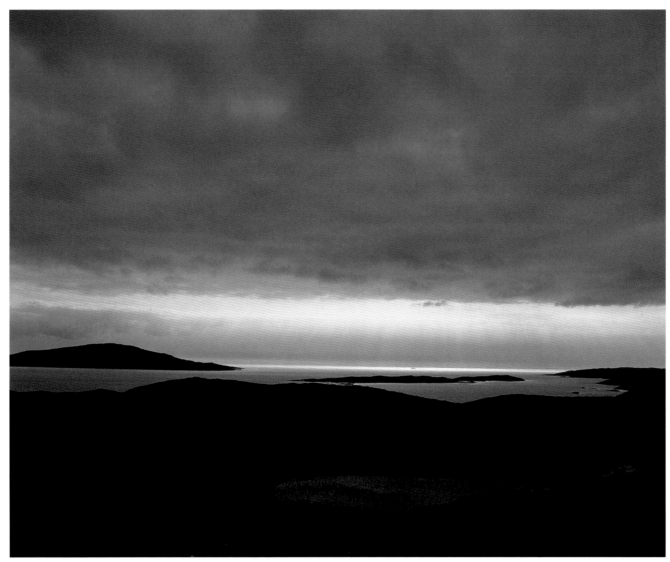

Taransay and the Sound of Taransay, off the west coast of Harris

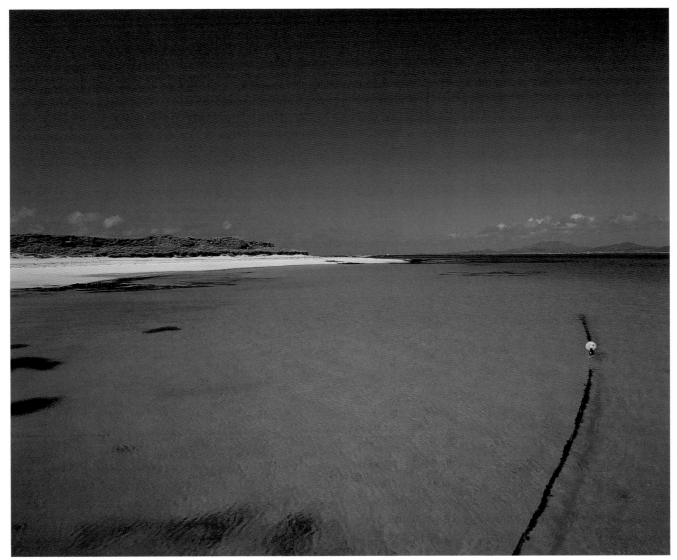

The Sound of Fuday from Eoligarry jetty, Barra

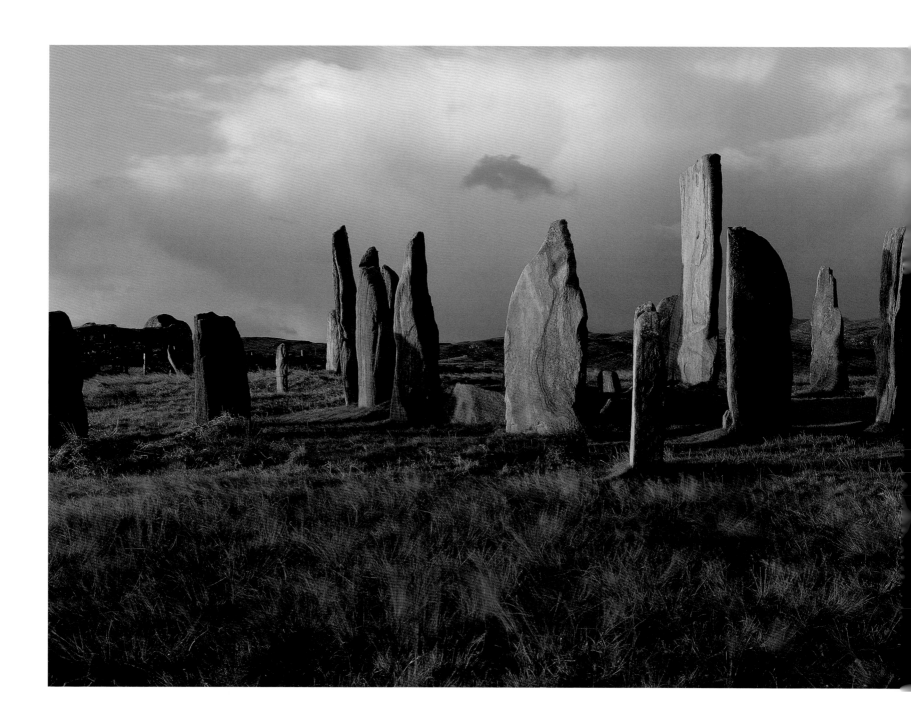

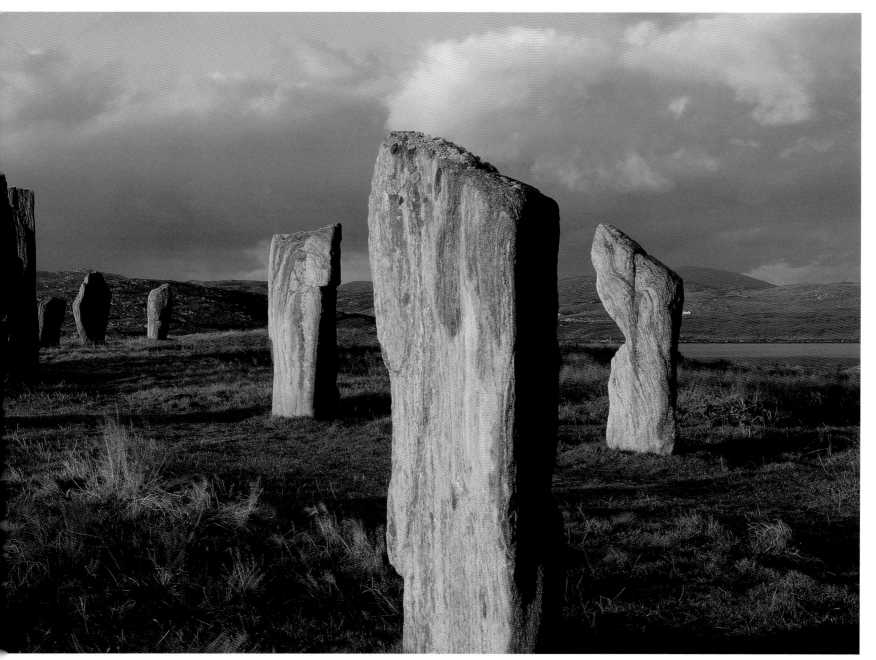

The Callanish stone-circle, Isle of Lewis

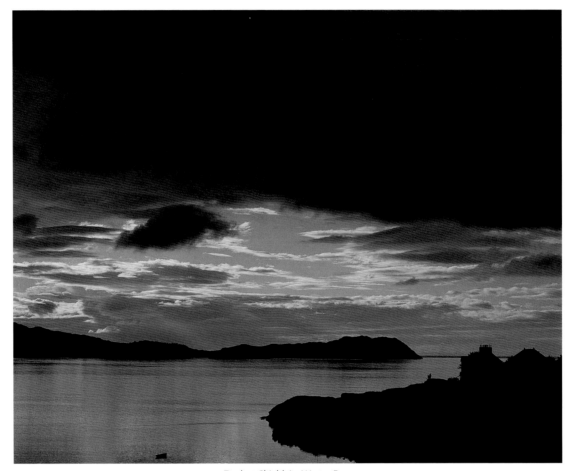

Dusk at Shieldaig, Wester Ross

THE WEST HIGHLANDS, FROM MOIDART TO TORRIDON, hold some of the finest country you could wish for, and though real wilderness is hard to find anywhere in Europe, some fragments still may be found here. Understandably, this is a great attraction for other than just native tourists and in summer the mobile homes from France, Germany, Italy and Scandinavia make virtual convoys on the roads and pack the campsites from late June to mid-September.

They wend their way along some of the most famous and beautiful glens and straths in the Highlands: Glen Garry, Glen Shiel, Strath Carron, Strath Bran, Glen Torridon and more. This is the heartland of the Highlands, and all our desire, all our history, is here—from Loch nan Uamh in Moidart where Charles Edwart Stewart came ashore at the start of the 1745 rebellion, to valleys like Glen Garry and Glen Shiel, ruthlessly cleared of their people a few decades later at the end of a process which began with the raising of a standard at Glenfinnan.

The depopulation of the Highlands which began after the '45 and continued, by one means or another, until after the second world war has in recent years been halted or even reversed, but not before a desert had been created—in the real sense, that is, of *a place which is deserted*. The wonderful 'natural' playground which the Highlands afford us today exists because the people were removed and never came back. As walkers, hikers, climbers and nature-lovers we all head north to enjoy these empty hills and glens, and we imagine—wrongly—that this is how it always was.

There is no doubt that the whole area is a paradise for walkers and climbers. Glen Garry has a fine range of hills along its northern flank, including the wonderfully-named 'Gleouraich' (The Hill of Roaring) and the other fine summits of Spidean Mialach and Sgurr a' Mhaoraich. Glen Shiel is a byword among hill-walkers and both the north and south sides of the glen boast long ridges of peaks with multiple summits and Munros. The Five Sisters, at the west end of the glen, are perhaps the most famous of the hills here.

North of Glen Shiel lies the biggest wilderness in the British Isles. Striking north from the A87 road you will not come across an inhabited dwelling until Strathcarron, some 35 miles' walk away. The Allt Bheithe (Glen Affric) youth hostel (reachable only on foot) is open part of the year; ten miles further on there is the abandoned hamlet of Carnach (houses boarded and shuttered); another five miles or so, the open mountan bothy of Maol-bhuidhe; finally, seven or eight miles short of Strathcarron, there is another bothy at Bendronaig. There are no roads (a private dirt-road reaches Carnach) and in three trips on foot through here I have met one other person in total. It may not be true, pristine wilderness in the Alaskan sense but it seems pretty good to me!

More fine mountains crowd the horizon north of Strathcarron, and to the west it's only a hop, skip and jump to Applecross and the most dramatic (and highest) public road in Britain. From the top of the 2000-foot pass at Bealach nam Ba, the summits of Meall Gorm and Sgurr a' Chaorachain are a mere stroll away, both offering superb views over Loch Kishorn and the hills of west Invernesshire. In Torridon we start to come across mountains all of whose summits cannot be reached by mere walking—at least some scrambling and even moderate rock-climbing is required. This is true, in varying degrees, of Liathach, Beinn Alligin and Beinn Eighe—the major peaks of the region—behind whose wall hides another gem of wilderness. The area enclosing the Torridon, Shieldaig and Flowerdale deer-forests, eighteen by eight miles, contains no road or house but all the landscape beauty you will ever need.

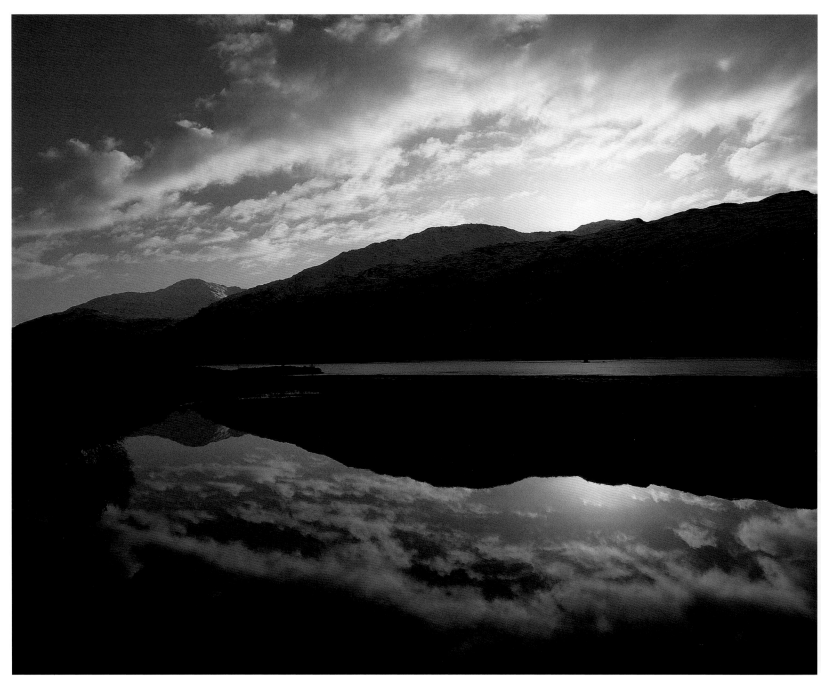

A winter dawn on Loch Eilt and the Moidart hills; Part I.

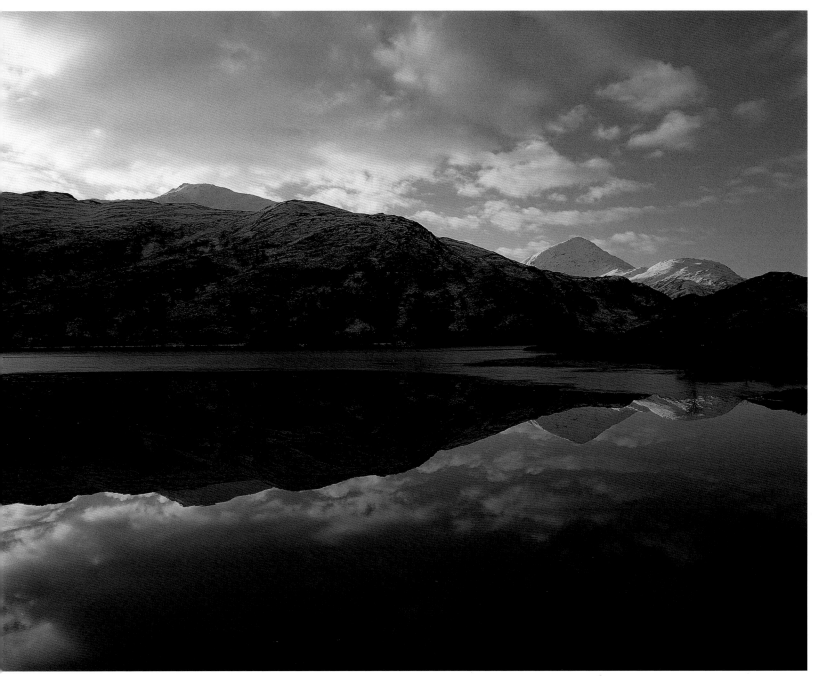

Loch Eilt and the Moidart hills; Part II.

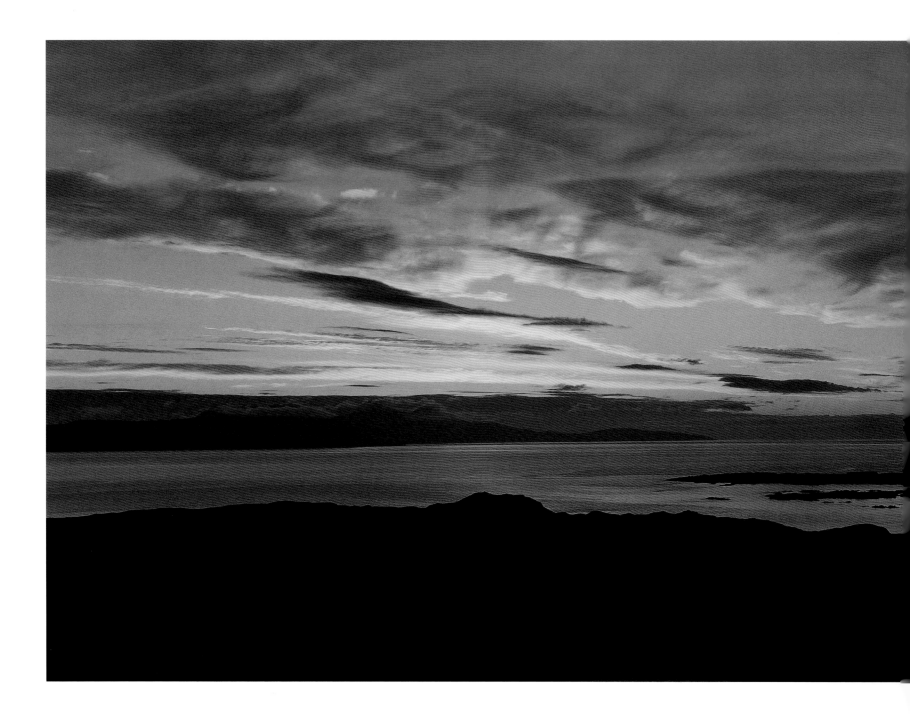

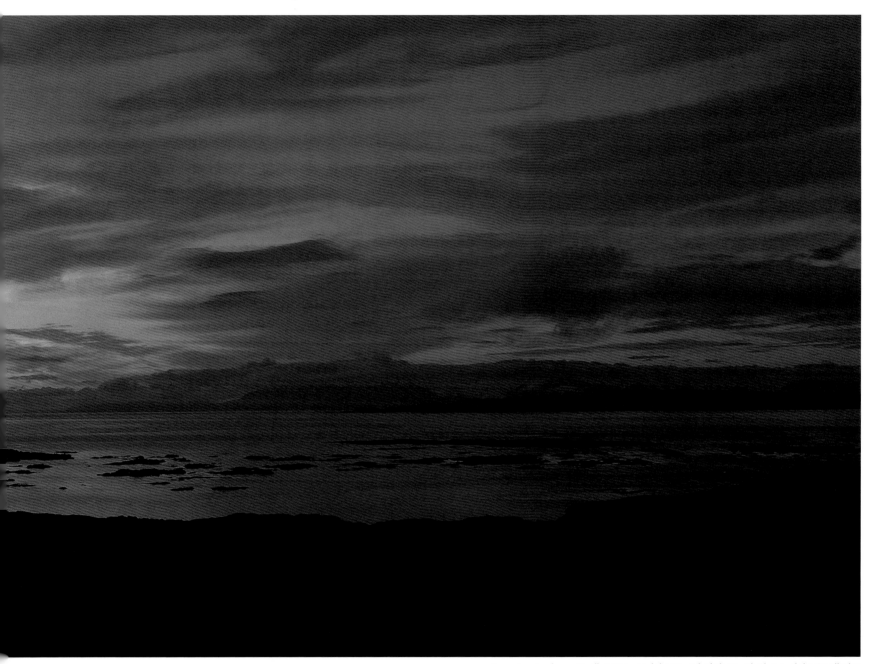

Sunset on Loch nan Ceall, Arisaig, and the Sound of Sleat with Skye and the Small Isles

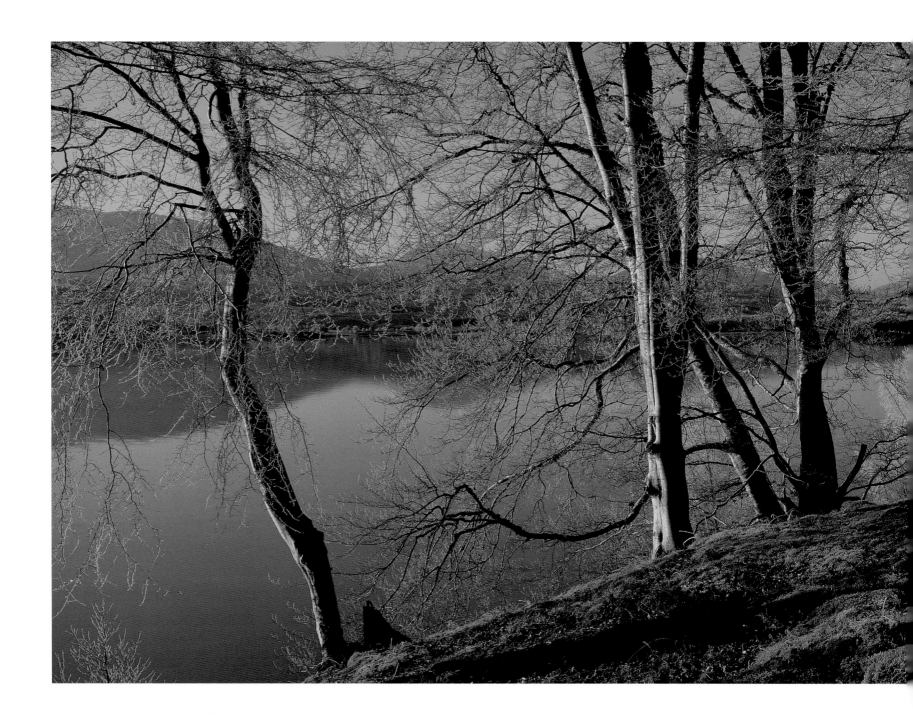

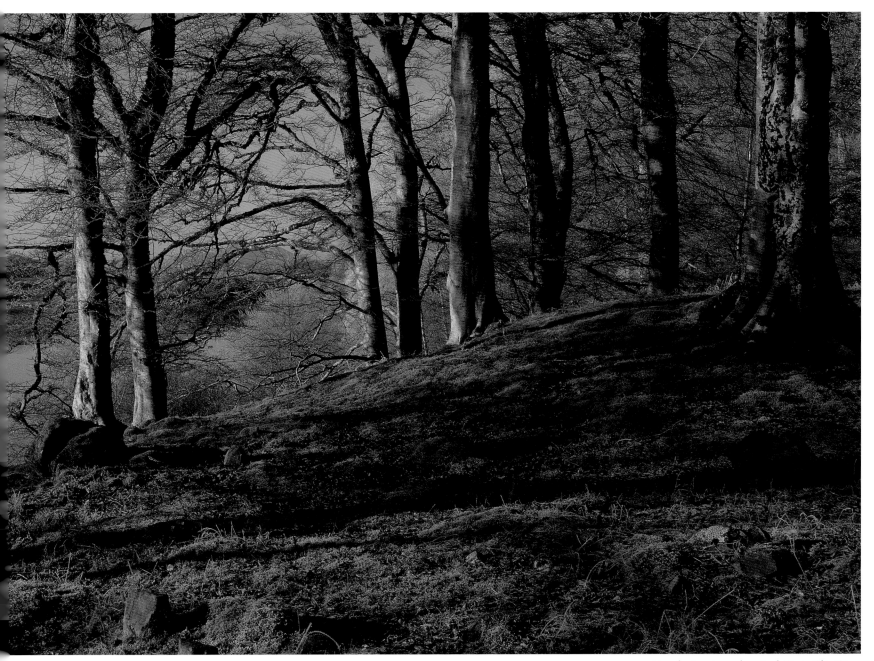

Hoar-frost on trees along Loch Garry, Glen Garry

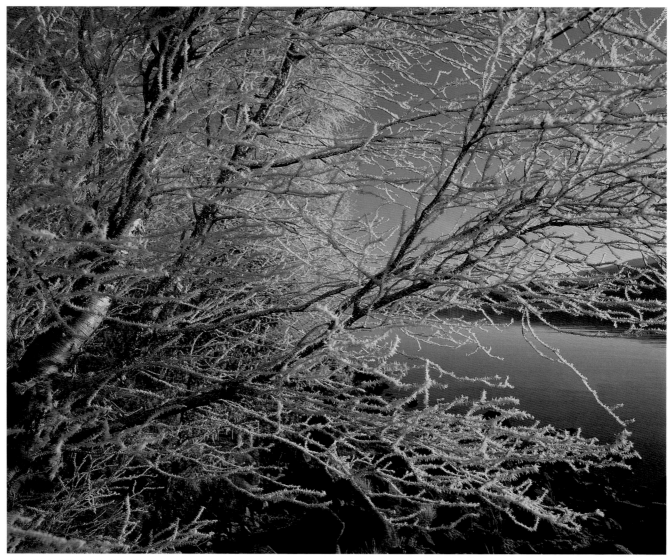

Hoar-frosted birches in Glen Garry

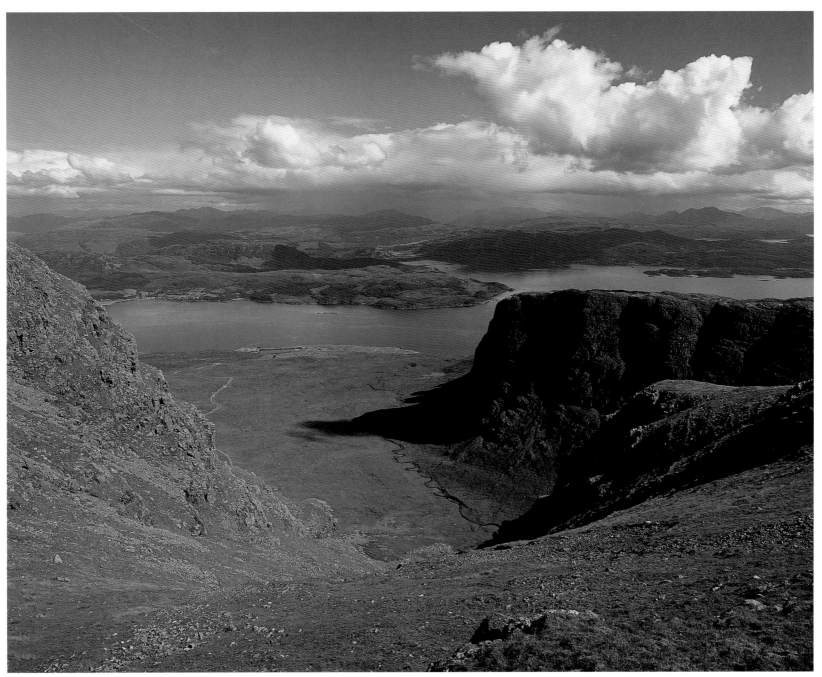

Meall Gorm, Applecross, and Loch Kishorn from Sgurr a' Chaorachain

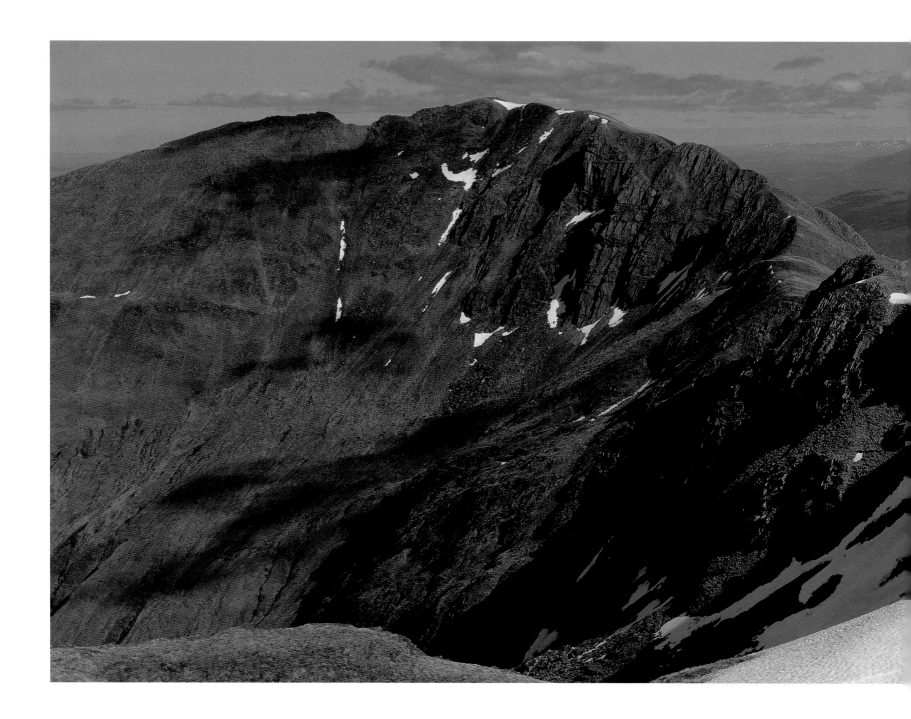

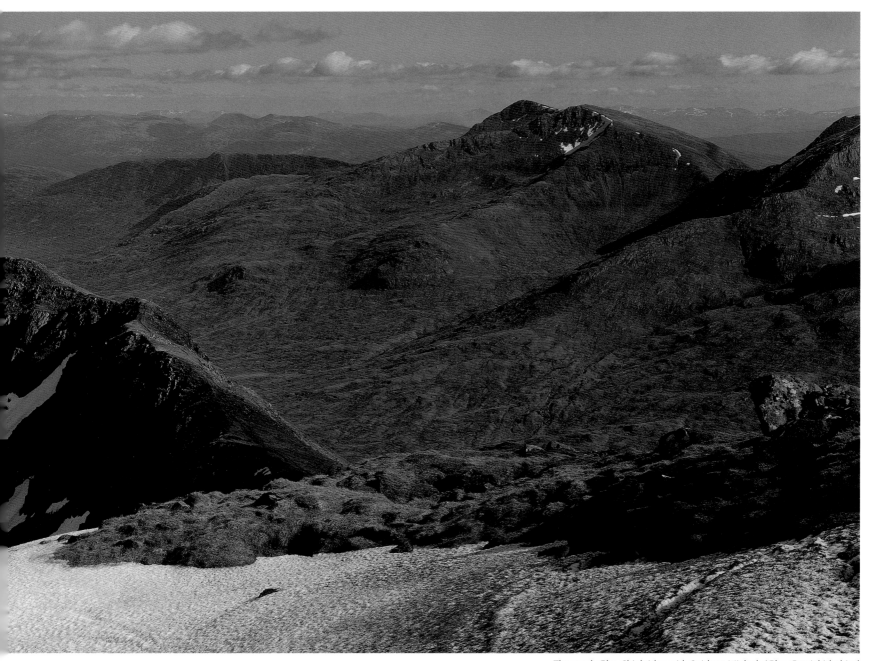

The south Glen Shiel ridge with Spidean Mialach (Glen Quoich) behind

Autumn in Dundonnell

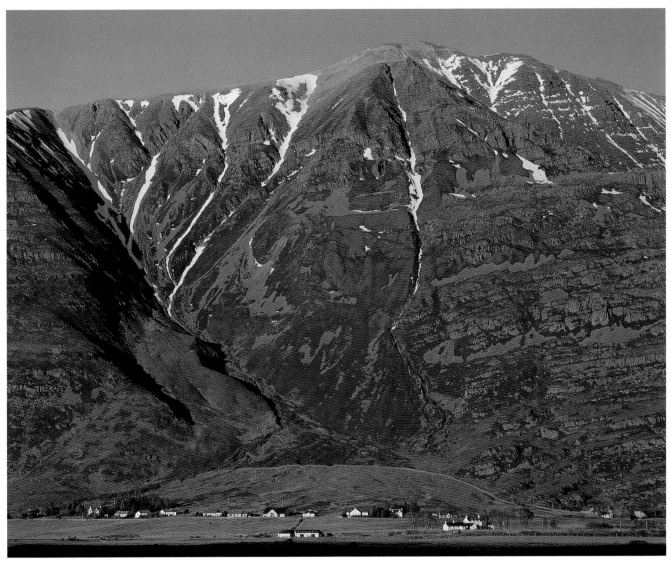

Torridon village and Liathach, from Annat

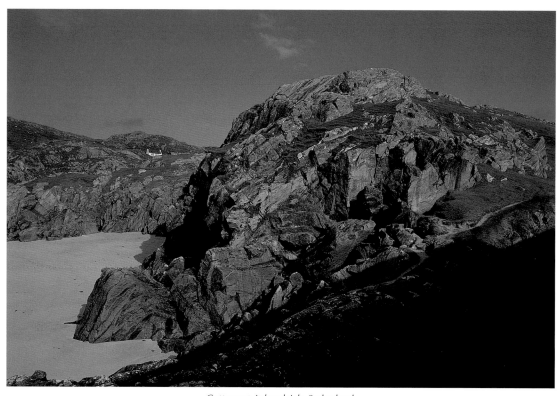

Cottage at Achmelvich, Sutherland

THE NORTHERN HIGHLANDS ARE MY SPIRITUAL HOME. I spent all my schooldays in east Sutherland; my family is still there and I am a frequent visitor. The quiet east coast has much to recommend it—less drama than the west, but many fine features. A fertile coastal strip backs glorious sandy beaches, most of which are empty 365 days a year, and immediately behind the farms and villages of the littoral rise the east coast hills. This region is a most important wild-fowl habitat, and in the shallows of the Beauly, Cromarty and Dornoch Firths and Loch Fleet thousands of duck and geese gather, in season, to rest and feed.

From the coast a series of narrow glens and straths snake back into the hills—Strath Carron, Strath Oykel, Glen Cassley, Strath Fleet, Strath Brora, Glen Loth and the Strath of Kildonan. These gentle glens conceal a turbulent and often cruel past, and the bracken and heather hide many a ruin. There is much here for the patient and enquiring visitor, and gentler landscapes to rest the eyes on, compared to the surge of the western mountains. But take any of those easter Ross and Sutherland straths and it will lead inexorably west. Large parts of the interiors of the counties are moorland, but mountains always hover around the periphery, crowding the horizon and emerging unexpectedly as you turn a corner. This is a lonely landscape; apart from the village of Lairg there is not a single settlement in the interior larger than half-a-dozen or so houses, and on the west coast north of Ullapool only the small villages of Lochinver, Scourie and Kinlochbervie.

Whereas a little further south most peaks form themselves conveniently into ranges, or are connected along an extended ridge, with An Teallach in Dundonnell we start to see a new phenomenon—the large, isolated, single mountain. It's true that some of these, like An Teallach, may almost be considered miniature mountain ranges in themselves, but essentially they are single mountains.

In the sublime landscapes of north-west Rosshire and west Sutherland the 'isolated single mountain' has its finest expression. One could argue over which individual peak is the most perfect example, for there are many to choose from and all are exceptional: Stac Polly, Cul Beg, Cul Mor, Suilven, Canisp, Ben More Assynt, Quinag, Ben Stack, Foinavon, Ben Hope, Ben Loyal—the mountains rear up from the sea of foothills around them, like prehistoric beasts above the primeval forest. This is a landscape like no other; once seen, never forgotten. Some of the best viewpoints are to the west of the mountains themselves, on the coast where again a band of relatively low-lying territory lends drama to the now distant but turbulent peaks. Thus the Coigach and Assynt hills from Achnahaird or above Polbain, Canisp and Suilven from around Lochinver, and Foinaven and Arkle from Achrieshgill.

North of Foinavon, Cranstackie and Beinn Spionnadh are the last spikes in the dragon's tail; beyond them the landscape subsides gently over a rolling moorland towards a north coast which lacks nothing in drama, with immense cliffs at Cape Wrath and Whiten Head, sea-stacks and gleaming beaches of white shell-sand. Between Cape Wrath and Kinlochbervie the wonderful strand at Sandwood (sometimes called the finest in Europe) hides itself away at the end of a long hike down a sandy track luckily too deeply pitted even for four-wheel-drive vehicles. Standing on the perfect arc of the beach, the surf hissing around your feet, there is nothing between you and Iceland except five hundred miles of green Atlantic rollers.

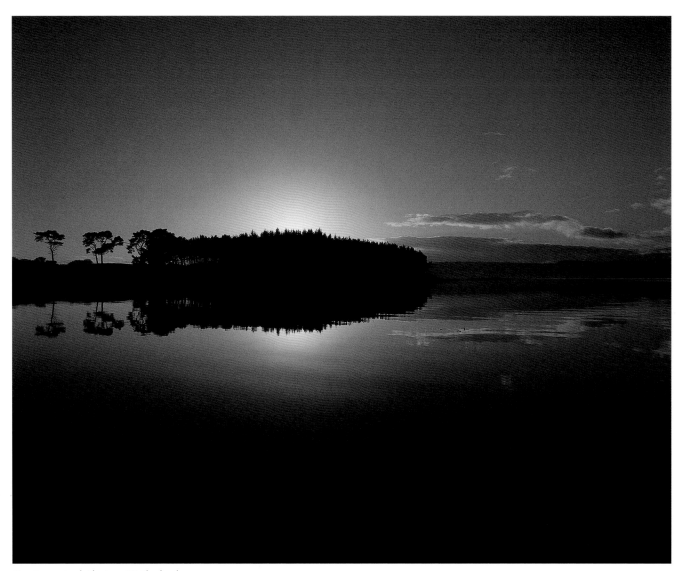

Evening on Loch Fleet, east Sutherland

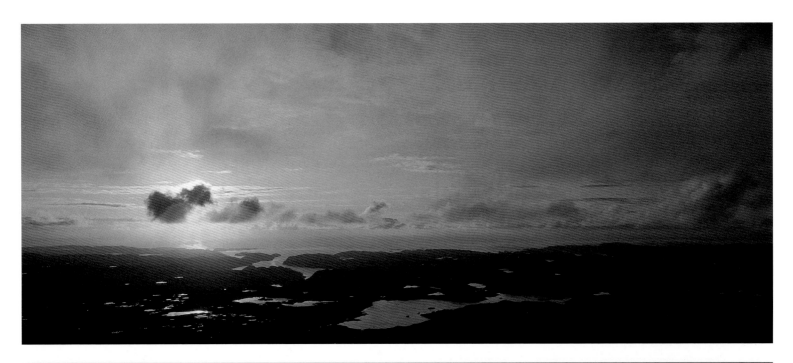

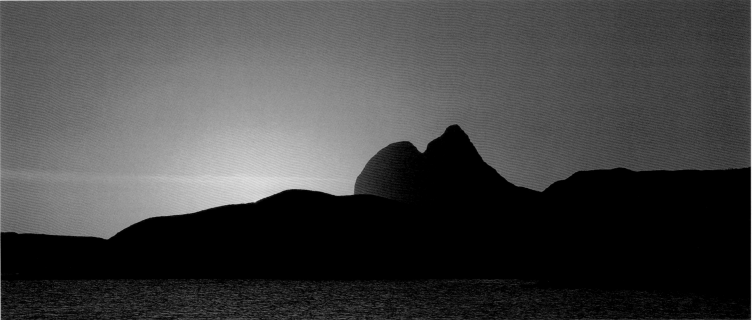

(Top) Loch Inchard and the NW coast from the summit of Foinavon

(Lower) Sunset on Suilven and the Cam Loch, west Sutherland

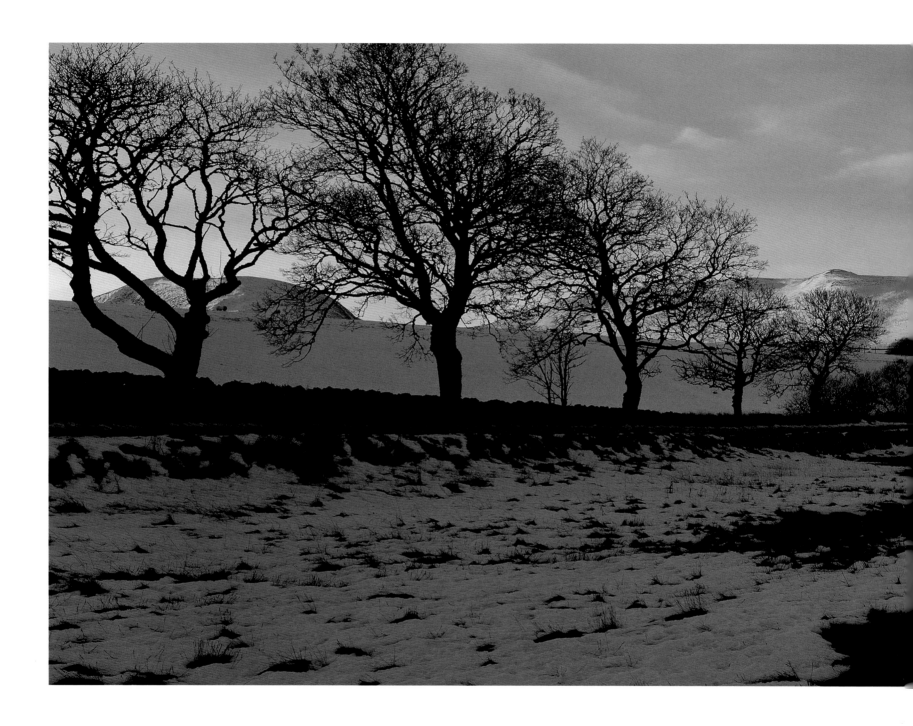

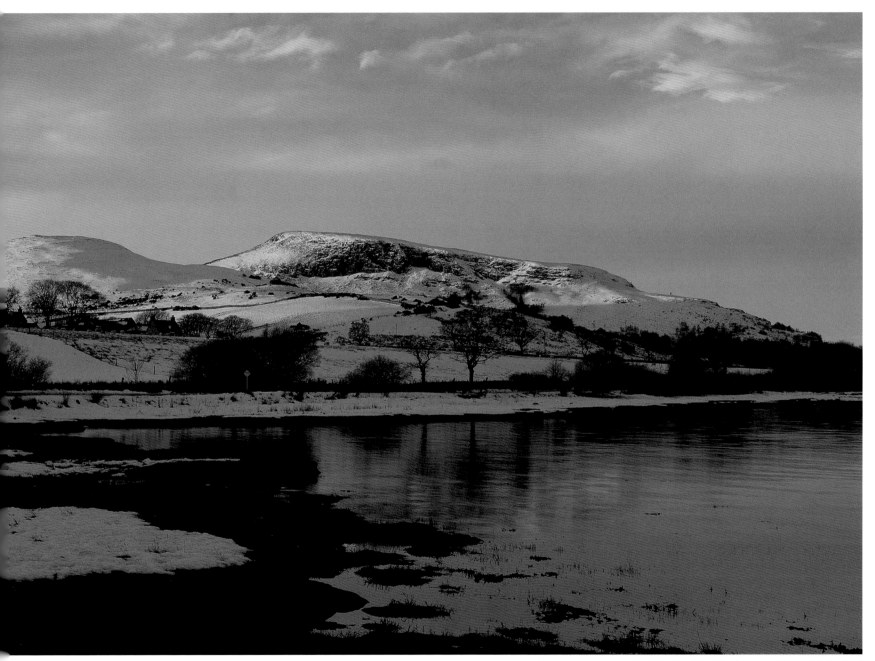

Loch Fleet and the Cambusmore hills, east Sutherland

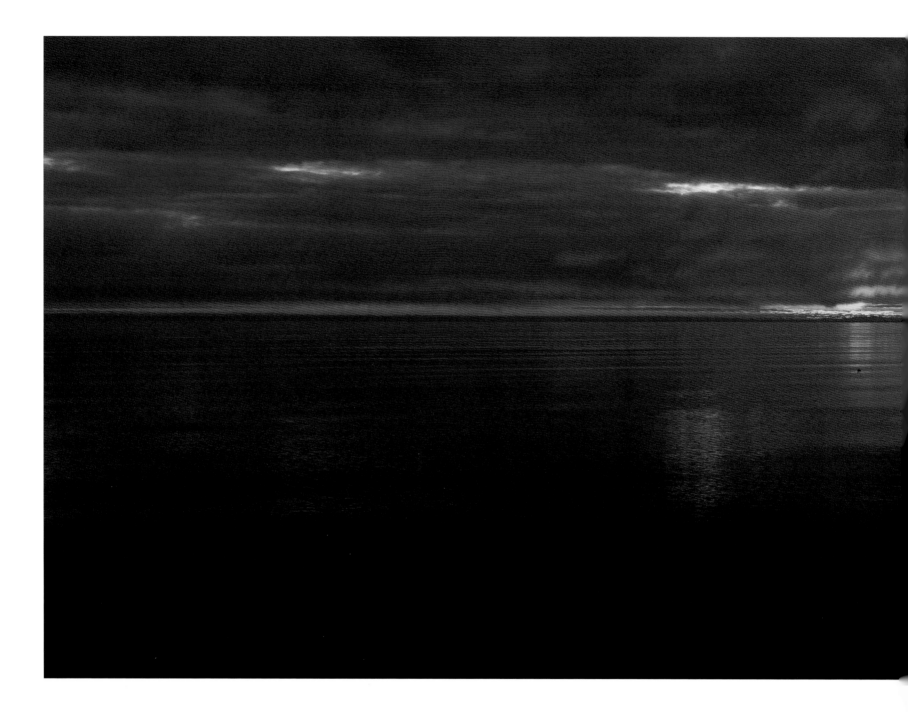

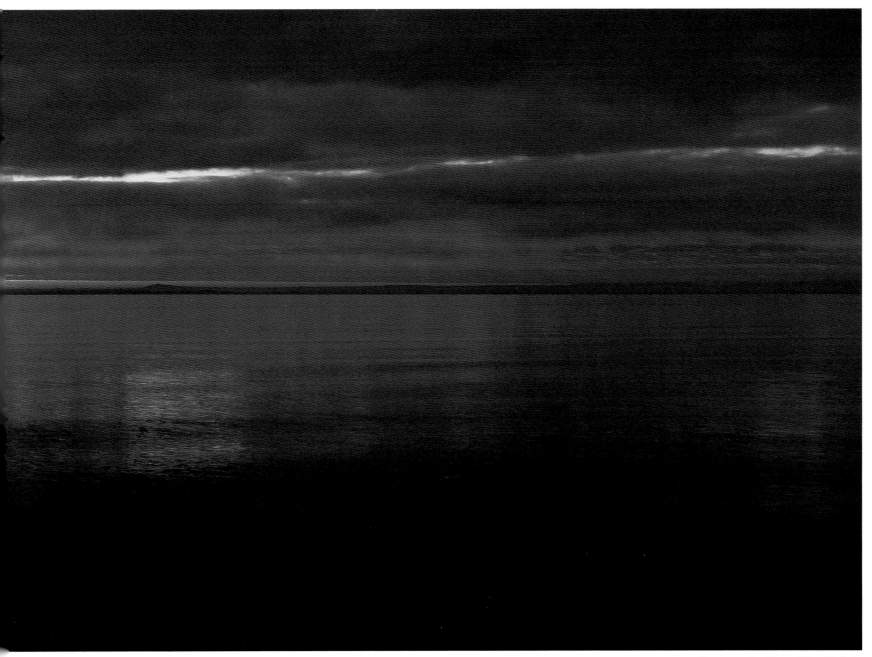

Dawn over the Moray Firth at Golspie

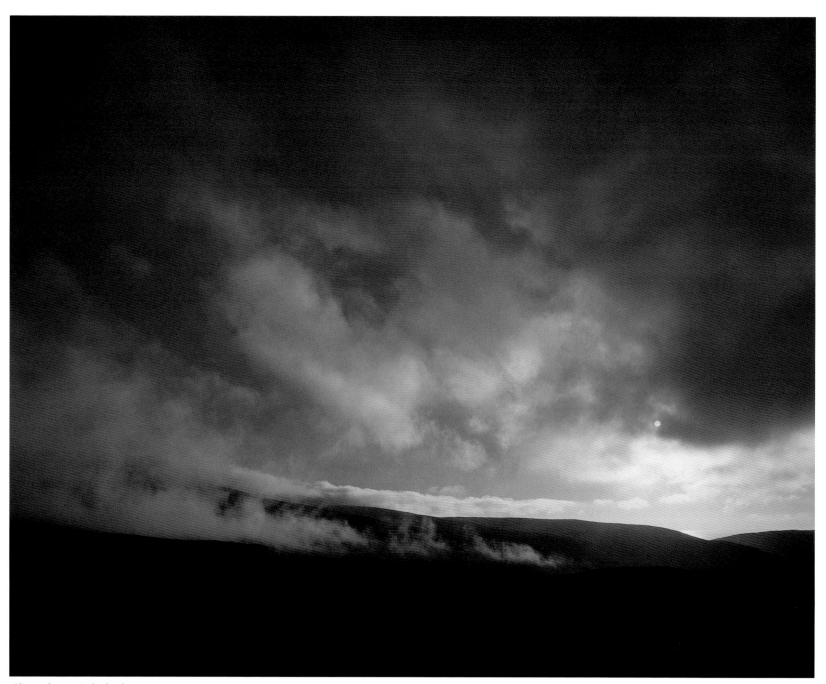

Glen Loth, east Sutherland

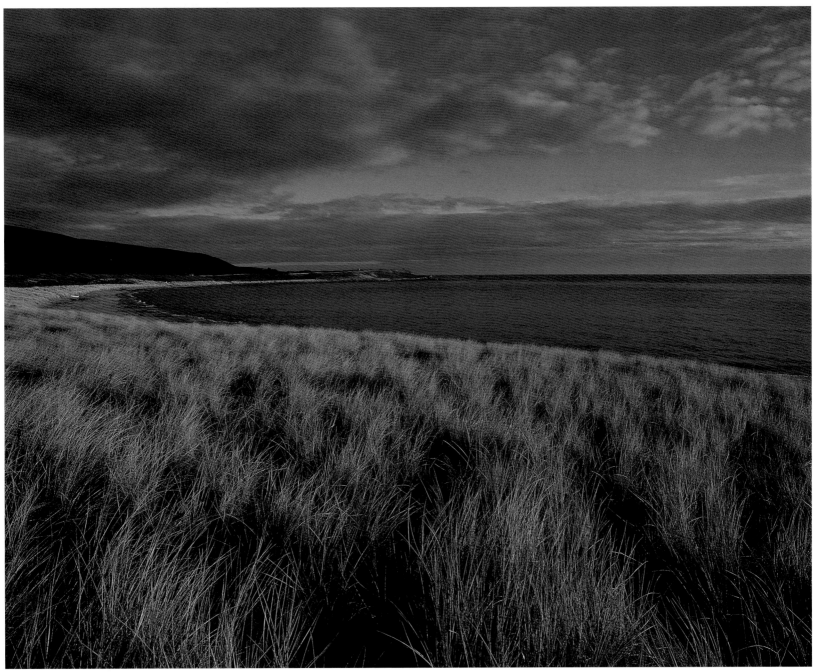

Bentgrass on the foreshore at Loth, east Sutherland

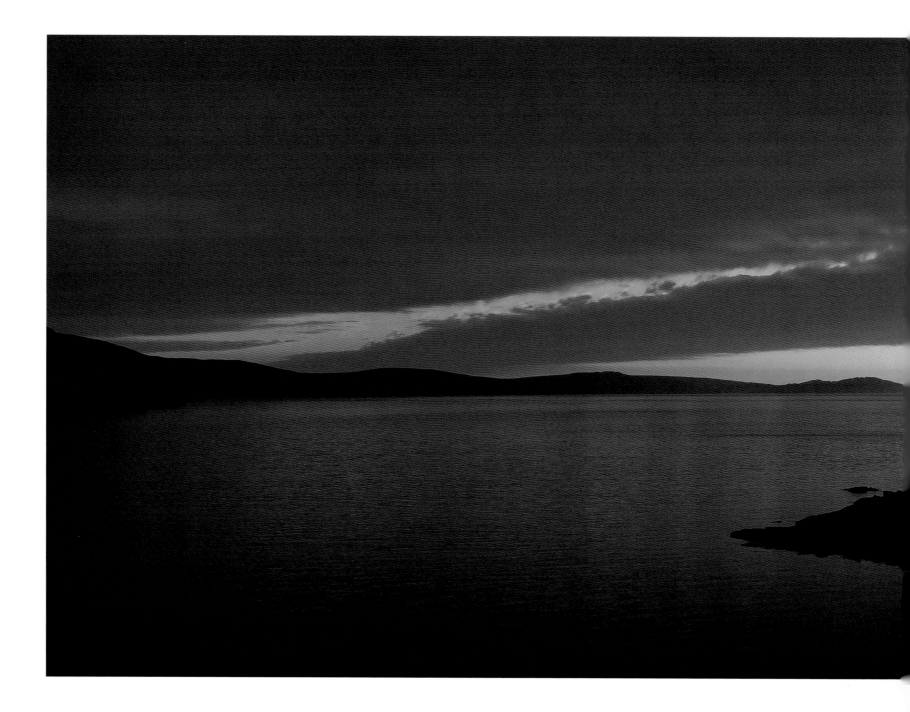

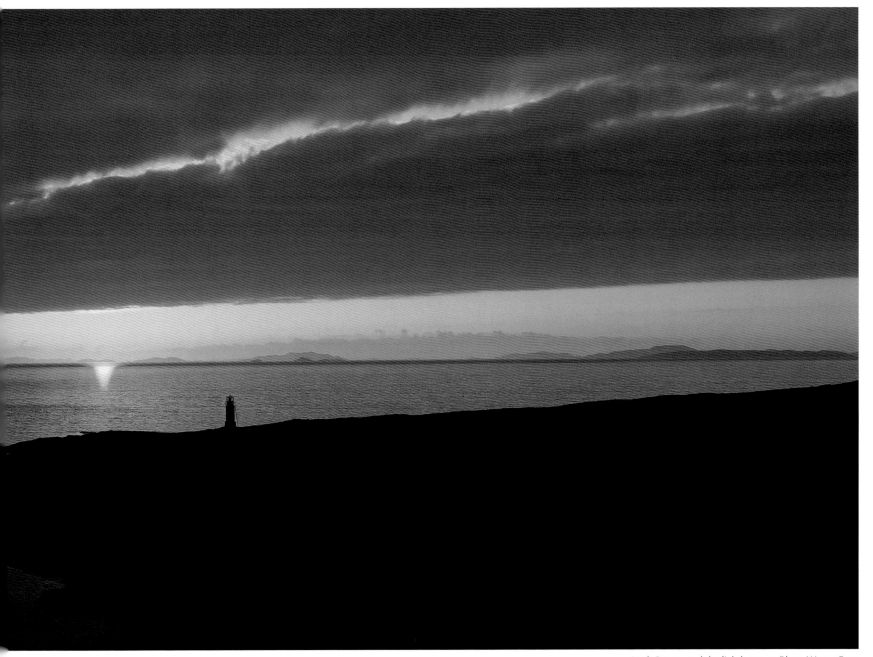

Loch Broom and the lighthouse at Rhue, Wester Ross

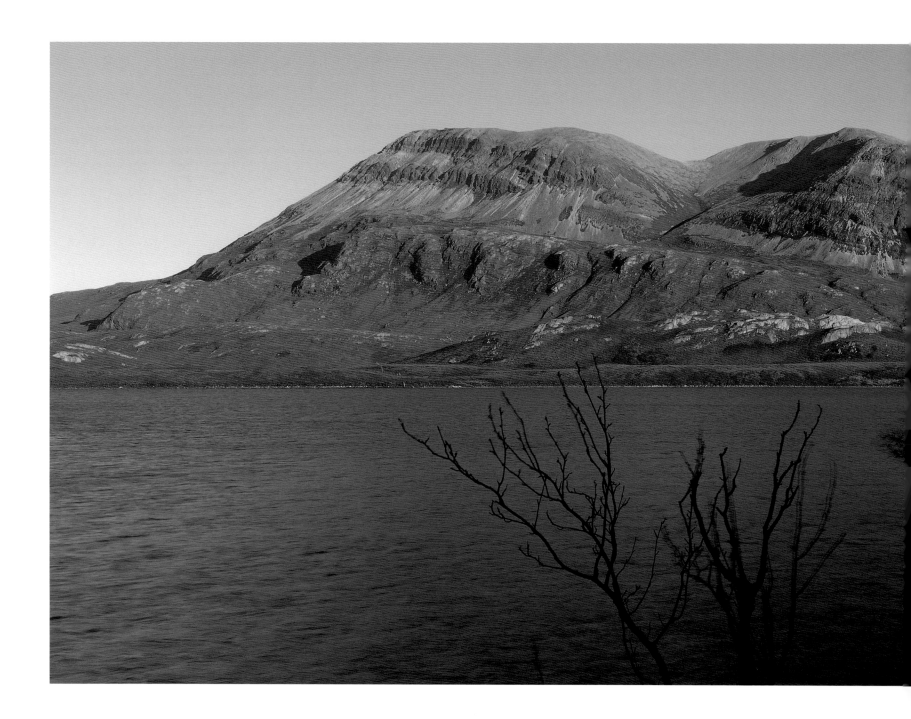

Loch Stack and Arkle, Sutherland

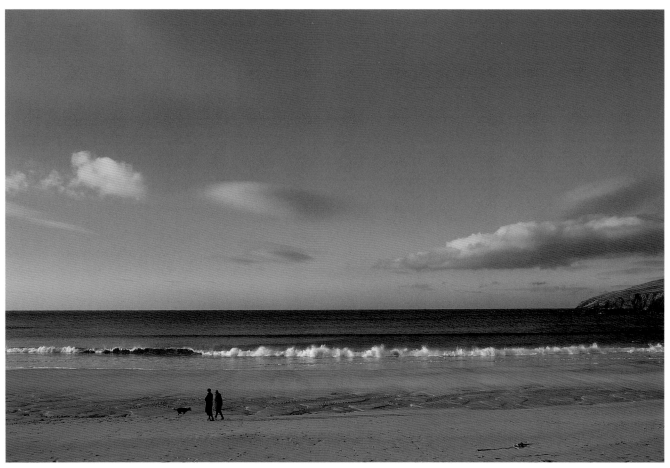

The beach at Bay of Stoer, west Sutherland

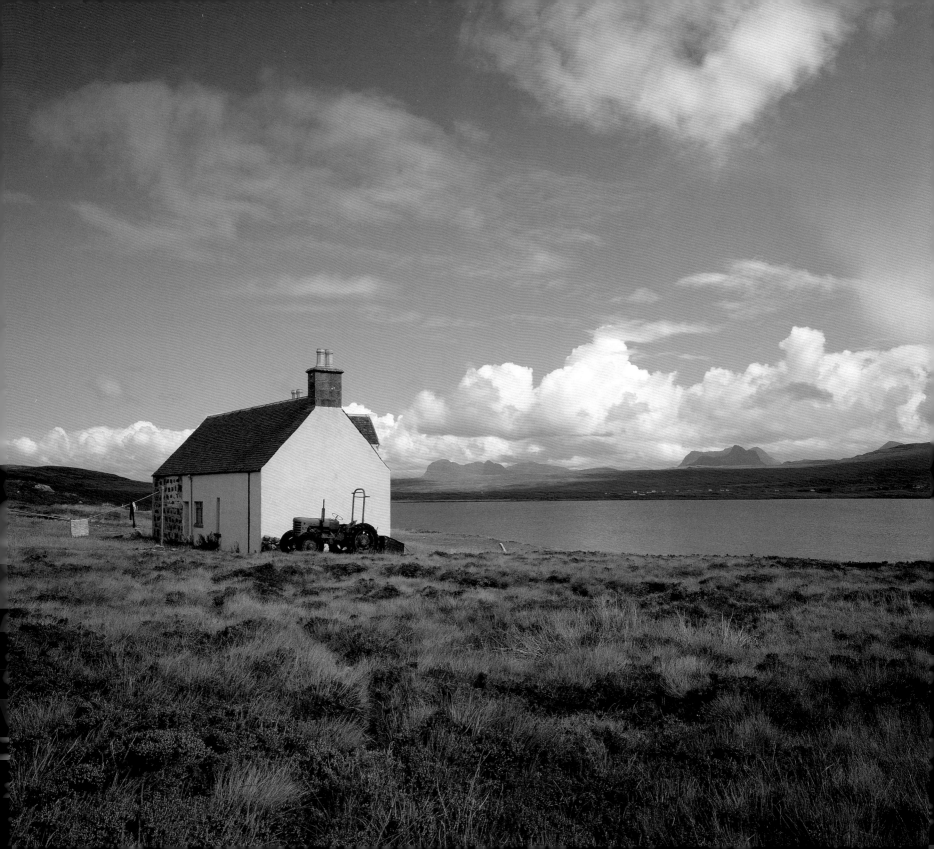

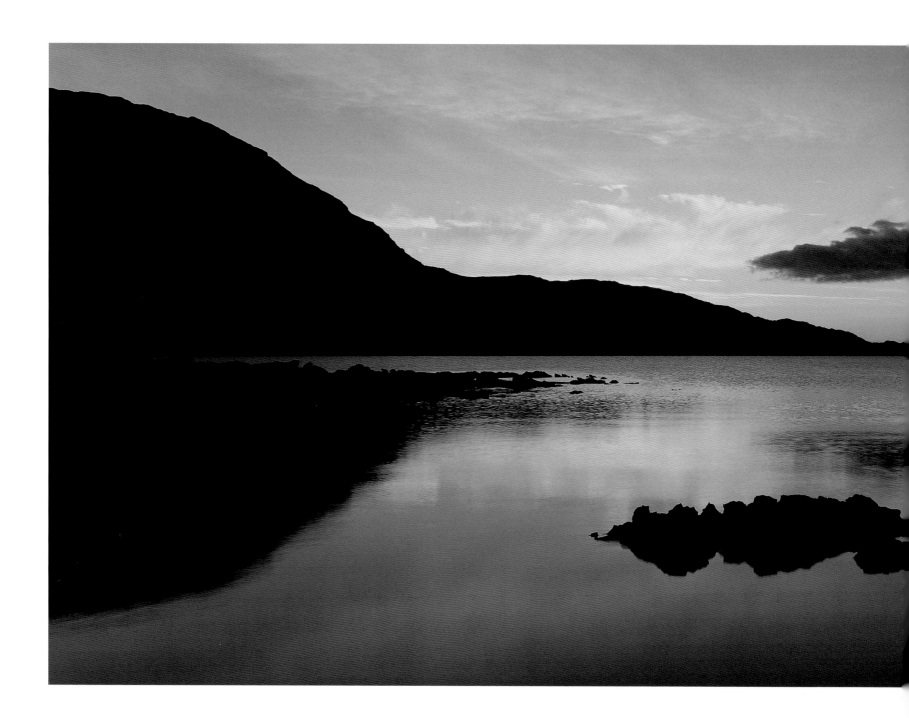

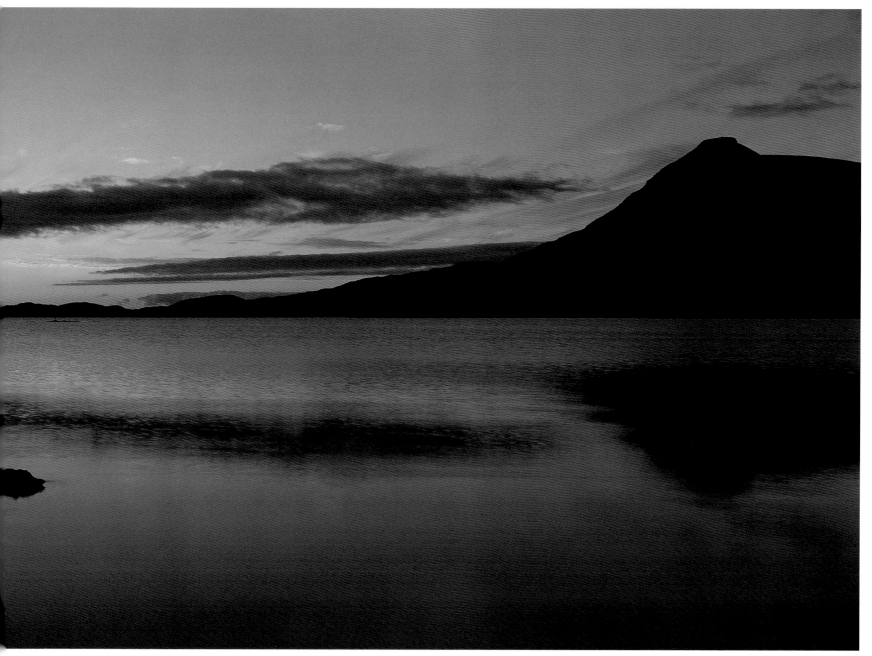

Loch Assynt, Sutherland, at sunset

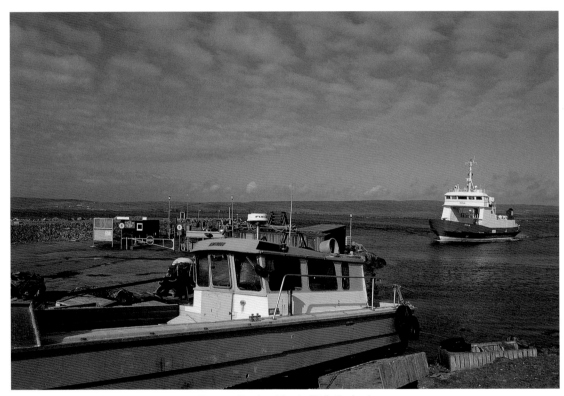

Boats at Gutcher, island of Yell, Shetland

THE NORTHERN ISLES HAVE A SCANDINAVIAN AIR and have strong ties across the North Sea to the extent that, twenty years or so ago, a plebiscite held in Shetland to decide whether they should be part of Scotland or Norway might easily have come up with the wrong answer (from a Scots point of view). I don't know whether the same still holds true today.

Both groups of islands, Orkneys and Shetlands, have strong Scandinavian links, a shared history, and cultural affinities both ancient and modern. These were the lands of the sagas, and the island people have never forgotten their Viking past; in more recent times Orkney and Shetland men have often gone to the whale-fishing fleets of Iceland and Norway, and the islands share with Norway a vast amount of common experience in deep-sea fishing and oil and gas exploration. Even their accents mark them out as far from typically Scottish, and both archipelagos have their own distinct dialects and vocabularies. All of this gives them a certain separation (more than just a simple stretch of water) from the rest of us on the mainland, which results in an extra little frisson when we visit them; these are almost foreign countries.

Flying in to Orkney on a fine day in spring or summer shows the islands at their best, and the Orkneys from the air have an almost tropical appearance. Their greenness is lush and startling, and the islands are fringed alternately with the gold of beaches and the white of surf against rock. Once on the ground the effect is somewhat dispelled as there are very few trees, let alone tropical jungle, but the greenness and fertility was no illusion and farming, especially of the dairy variety, is alive and well in Orkney. Those of us who are devotees of Orkney cheese and butter (and

shortbread) already knew this, of course.

Another wonderful thing about Orkney is the wealth of archaeology, the ready access to it, and (for anyone who has visited Stonehenge) the complete absence of crowds. On a summer's day you can visit the marvellously-preserved neolithic village at Scara Brae and, apart from the guardian, have the place almost to yourself; the same is true of the other famous sites at Maes Howe, Stenness and Brogar, and these are not the only ones.

The Shetlands are harder, harsher. There are few soft-sand beaches here and flying in, you would never make the mistake of thinking you were in the coral seas. Black cliffs and spray-drenched skerries are more the order of things here, rocky hills, craggy islands clinging on for dear life, and if you have arrived by ferry from Aberdeen you probably know already how stormy these seas are. Either way, once you have arrived on *terra firma* things are less dramatic and more welcoming. There is a distinct northern feel—many of the buildings look more Scandinavian than Scottish—and if you have ever been to any of those countries, especially Iceland, it is easy to make the mistake of believing yourself back there.

The further you go, out to the outer isles, the more of a frontier atmosphere there is, and an increasing sense of remoteness; people on the likes of Unst and Fetlar have learned to be very self-sufficient. It is a favourite outer island joke to claim that people come across from Kirkwall for a day and say they could never live on an island.

Standing on the gently-shelving beach at Burrafirth in the north of Unst with the hills of Hermaness and Saxavord rising to left and right, the phantom longboats are right there, rounding the headland, drawn up on the sand.

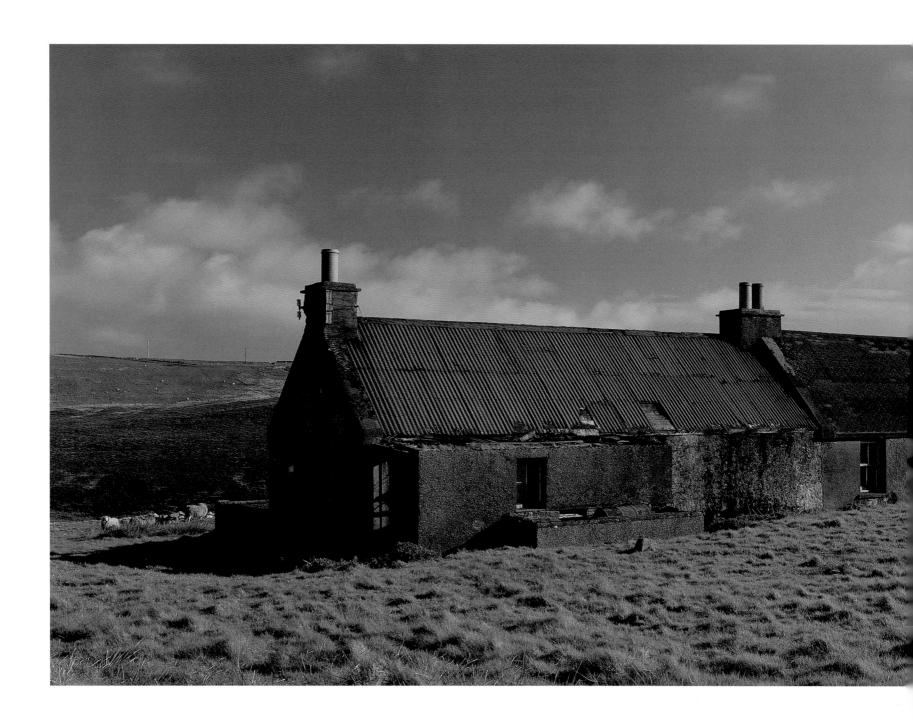

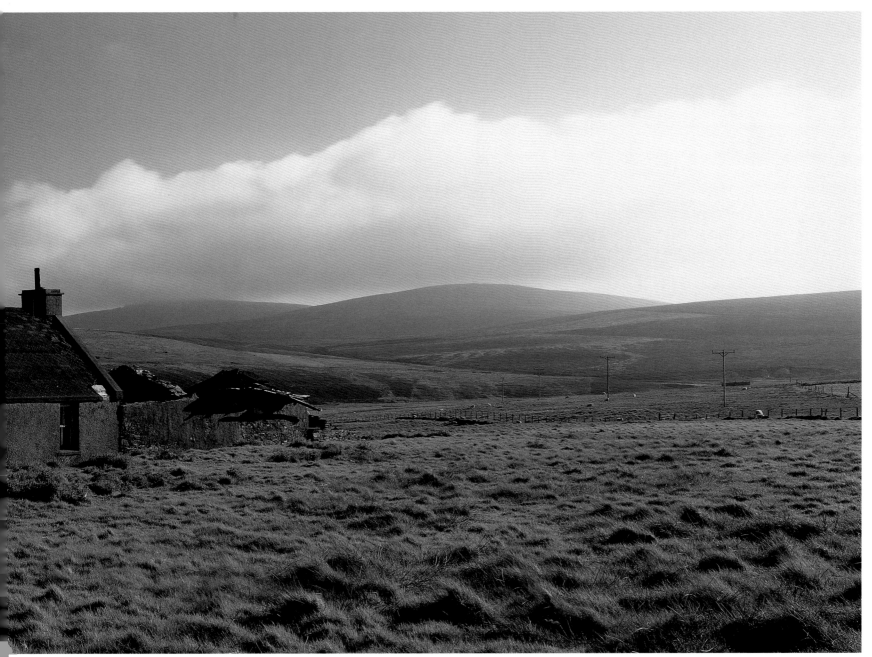

Abandoned house at Quoys, island of Unst, Shetland

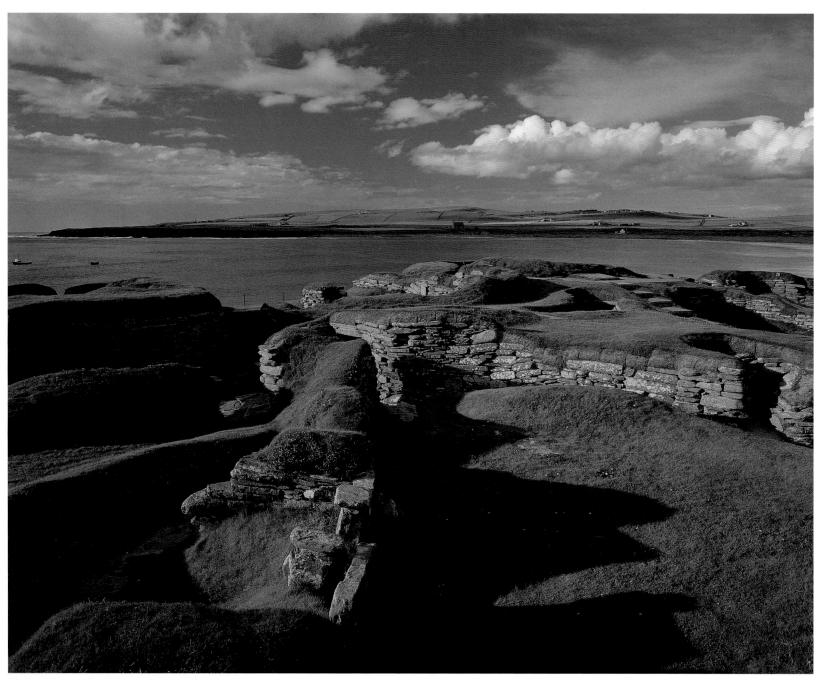

The Stone Age settlement at Scara Brae, Orkney

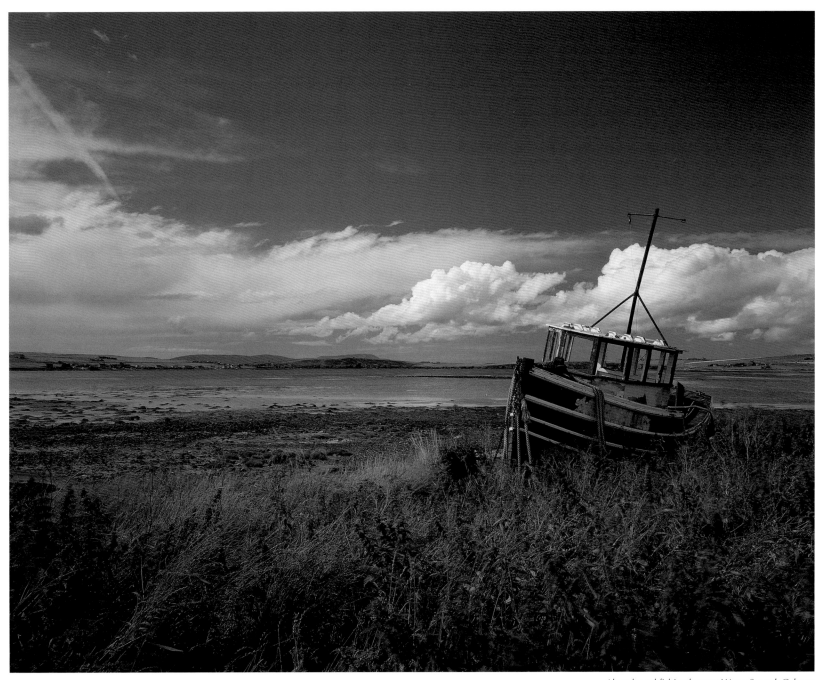

Abandoned fishing-boat at Water Sound, Orkney

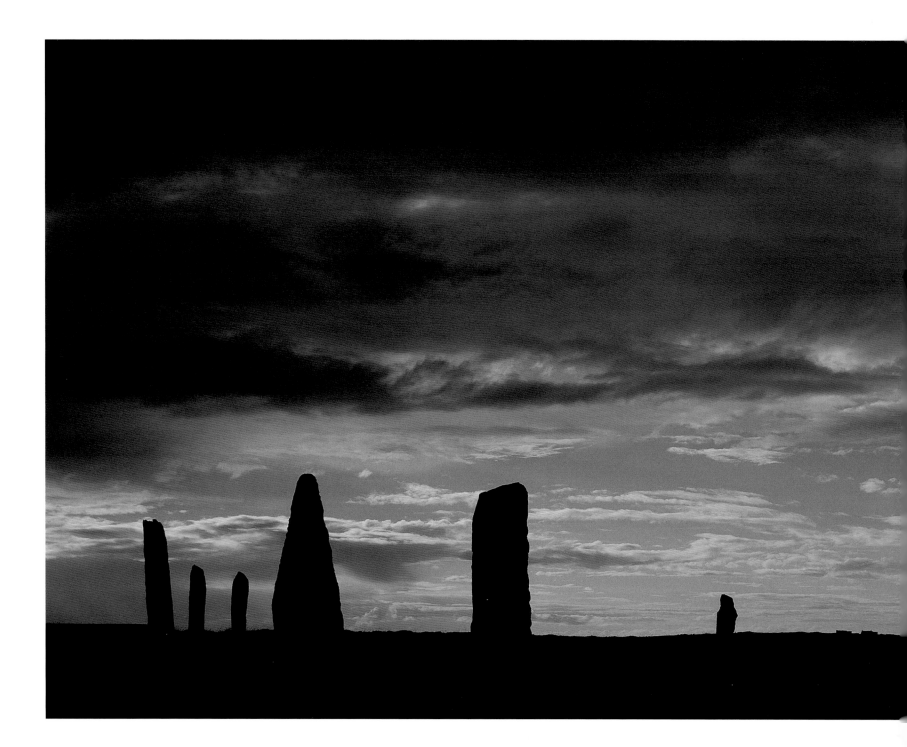

Neolithic stone circle at Stenness, Orkney

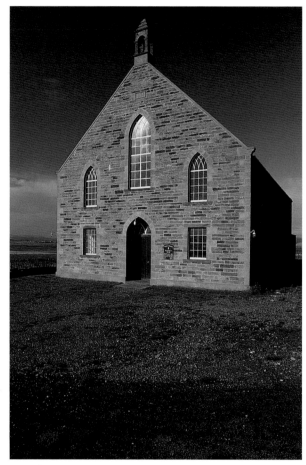

Church at Twatt, Birsay, Orkney

Sunset at Birsay, Orkney

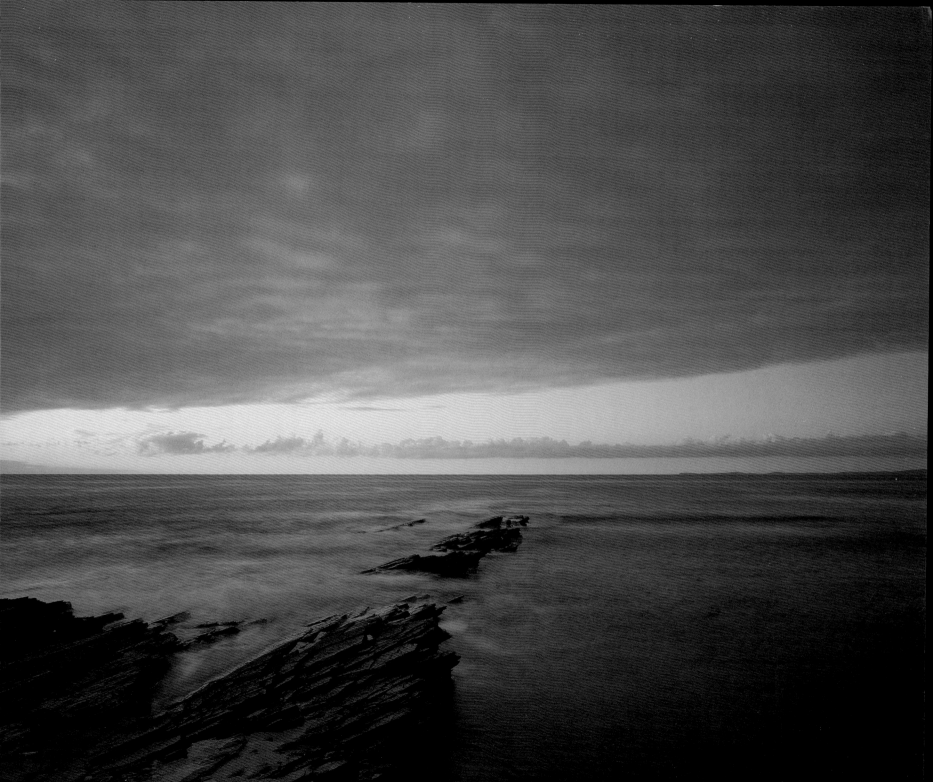

David Craig was born in Aberdeen in 1932. He has a daughter and three sons. He is married to the writer Anne Spillard. He has taught in Scottish schools, the Workers' Educational Association in Yorkshire, and universities in Sri Lanka and England. He has published many poems, stories and critical works. His books in print are *Native Stones*, *On the Crofters' Trail*, and *Landmarks* (all in Pimlico paperback) and *King Cameron* (a novel, published by Carcanet Press).

David Paterson was born in Perth in 1945. He is married and has a son. After a brief career as a chemical engineer, he turned full-time to photography in 1971 and worked for the next 25 years as an advertising and commercial photographer. In the late 1980s he also began an involvement with publishing. He has since published over a dozen books on landscape subjects ranging from Scotland to the Himalayas and for the past ten years has run his own publishing company.

David Craig and David Paterson have been working for some years on a project concerning the landscapes of the Highland Clearances. The intention is to publish this collection of new writings and images in book-form, some time in 2004. More information on David Paterson's photography, the Highland Clearances, and progress towards publishing the new Clearances book can be found on the website **www.wildcountry.uk.com** which also contains details of other books for sale.

Titles in series with this volume (previously published by Peak Publishing):
The Cape Wrath Trail: A 200-Mile Walk thro' the NW Highlands (ISBN 0 9521908 18)
Heart of the Himalaya: Two decades of travels in deepest Nepal (ISBN 0 9521908 26)
A Long Walk on the Isle of Skye: A 75-mile walk through Skye (ISBN 0 9521908 42)
Blue Horizons: Three photographers present a world travelogue (ISBN 0 9521908 50)
London - City on a River: Major photo-essay on a world capital (ISBN 09521908 77)
(For more information on these please visit the website)